SOUND OF SNOW FALLING
Maggie Umber

Title Design & Spot Illustrations: Sarah Ferrick
Production Design: Raighne

Published by 2dcloud
2002 23RD AVE S MPLS MN 55404
2dcloud.com

DISTRIBUTED TO THE TRADE
In the US by Consortium Book Sales & Distribution | www.cbsd.com
In Canada by Publishers Group Canada | www.pgcbooks.ca
Orders: (800) 283-3572

First Edition, February 2017
Library of Congress Control Number: 2017932937
ISBN: 978-1-937541-14-9

Printed in Korea

2DCLOUD

UMBER BEAUTIFULLY
USES COMIC FORM
TO TAKE THE READER
THROUGH INTIMATE
MOVEMENTS IN
NATURE.
 AIDAN
 KOCH

MAGGIE UMBER'S WORK
IS SIMULTANEOUSLY A
BREATHLESS, QUIET
STRETCH AND AN
ENORMOUS, ORCHESTRAL
VOICE. I DON'T KNOW
ANYONE ELSE WHO
CAN CREATE SUCH
VOLUME THROUGH
SILENCE.
 SARAH
 FERRICK

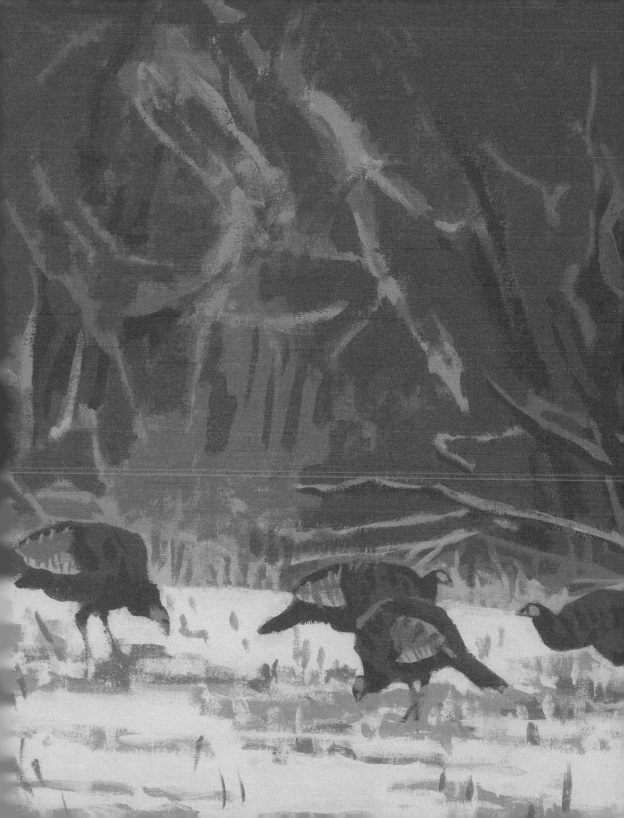

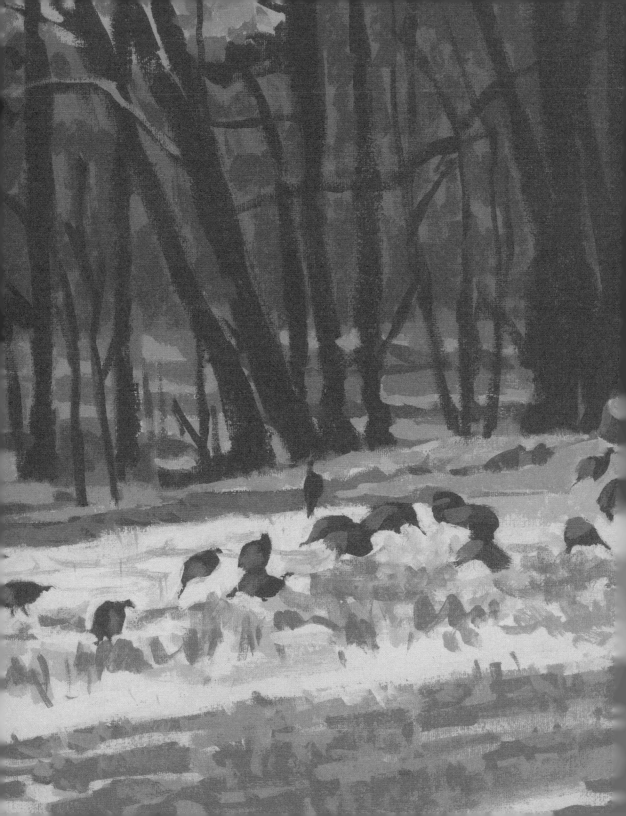

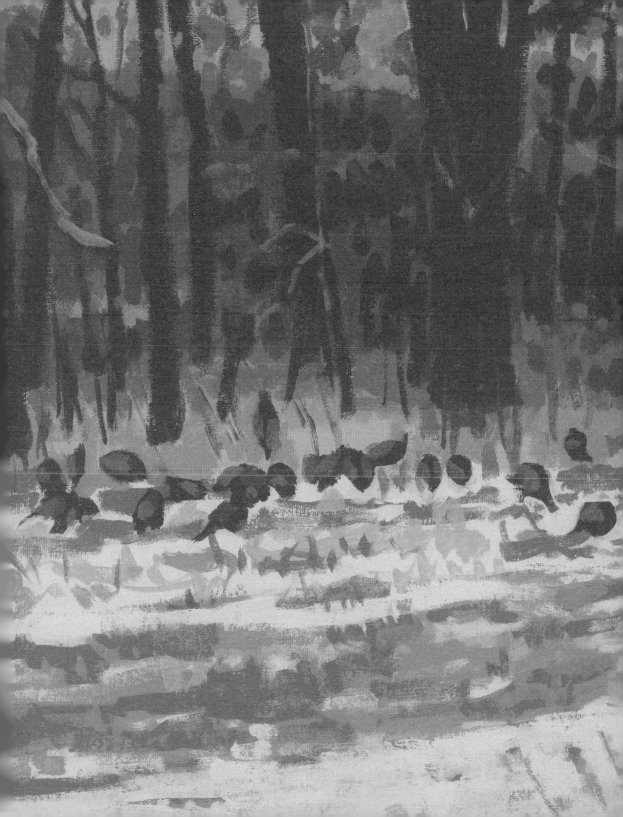

SOUND
OF
SNOW
FALL
ING

MAGGIE
UMBER

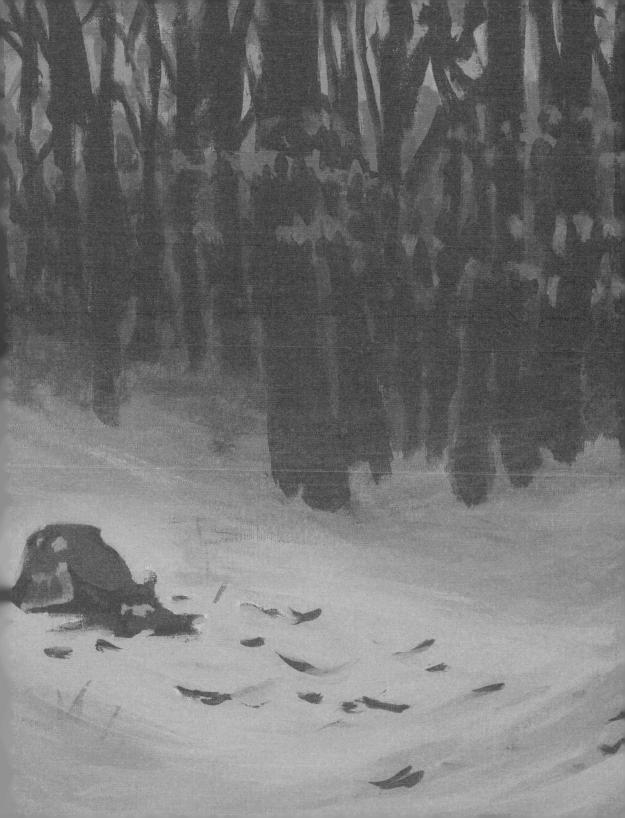

FORE

WORD

It is challenging to reply to a request to be part of something so beautiful that silence alone seems like the only appropriate response to it. Such was my reaction to artist and associate publisher Maggie Umber's invitation to write a foreword to her latest book of original artwork entitled *Sound of Snow Falling* published by 2dcloud. None-the-less it is a privilege and honor to do so. This entrancing book intimately follows the lives of a pair of Great Horned Owls – and a multitude of their neighbouring plants and animals – through winter, spring courtship and nesting.

As an owl researcher I recognize and embrace the importance and need for objectivity in the pursuit of evidence-based scientific truth. Based on over 35 years of experience studying owls in the wild with my indefatigable research partner and better half, Patsy, I can assure you that the ecology, behaviors and natural history portrayed in this book are accurate and factual. After viewing each page many times, it was clear to us that Maggie had indeed done her homework over the years while creating these ecologically accurate works of art.

She has exhibited a deep knowledge and

understanding of the species depicted in these stunning paintings! Perhaps what caught me by surprise while viewing this book was how emotionally stirred I felt by the artist's efforts. Seldom, if ever, do scientific journal articles cause strong emotional reactions in their target audience, namely other scientists. However, science is but one way to learn about the world of nature or to influence others to conserve it. Artists observe and convey information about the nature of things in different ways than science, and both are important paths to knowledge. Scientific research, while important, may not be the most effective way

to affect people's behaviour. Providing people with a personal experience with nature can be more effective at changing conservation attitudes.

Herein lies the important role for works such as *Sound of Snow Falling*. The viewer will feel drawn into the natural world of the owls. The experience of viewing it will change you.

Art is not simply entertainment. It serves to inspire, teach, and influence. It is experiential. Given the current state of nature around the globe the need for a motivated society to embrace a conservation ethic is greater now than ever before. Not everyone has the opportunity nor skill to escape into nature for days or weeks at a time to shed our cultural or civilizational blinders. This book will be a passport or ticket for these folks, and just may convince them to seek out such important experiences first hand. Even the title *Sound of Snow Falling*, which likely relates to the silent flight of owls, is clever, instantly attractive, and thought provoking.

The lack of text in *Sound of Snow Falling* creates an influential and educational work of art that is global in its reach, instantly transcending culture and language barriers. I think it carries a conservation impact by immersing the viewer into the lives of largely nocturnal wild creatures and making the person gazing at the pages feel like they are part of that world. The images convey information in a clear and yet subtle manner.

The main characters, the pair of Great Horned Owls, do not appear until a few pages into the book – much like one's experience living in an area with often reclusive nocturnal resident owls. The first evidence of their existence is often indirect. One more brilliant example of the artist's skill is co-depicting the whiteness of the moon and the owl's eggs, and later linking the lu-

nar cycle to egg development conveying information on how long owl eggs take to develop and hatch.

Great Horned Owls are formidable predators that catch and consume a large variety of wildlife. Established breeding pairs are typically year-round residents. This species nests early in the year and they do not make their own nests. As a result, they get first pick of existing stick nests that were built by other bird species the previous summer. This extraordinary collection of art shows these owls and other creatures in the context of their environment, experiencing tragedy and joy while surviving in a world that is challenging as well as beautiful.

This book allows you to follow the experiences of such species with which we share this planet. The frequent portrayal of this

world at night opens our senses and minds to what is likely a previously alien and foreign environment for most people. The next time you gaze at the moon or stars you will remember that a multitude of creatures are also active at night in such silvery light. Maggie's skill, wit and occasional humour makes for an adventurous experience for people of all ages and background. My copy of *Sound of Snow Falling* will be well worn and will occupy a treasured place on our coffee table.

— James Duncan, Balmoral, Manitoba, Canada | 17 July 2016

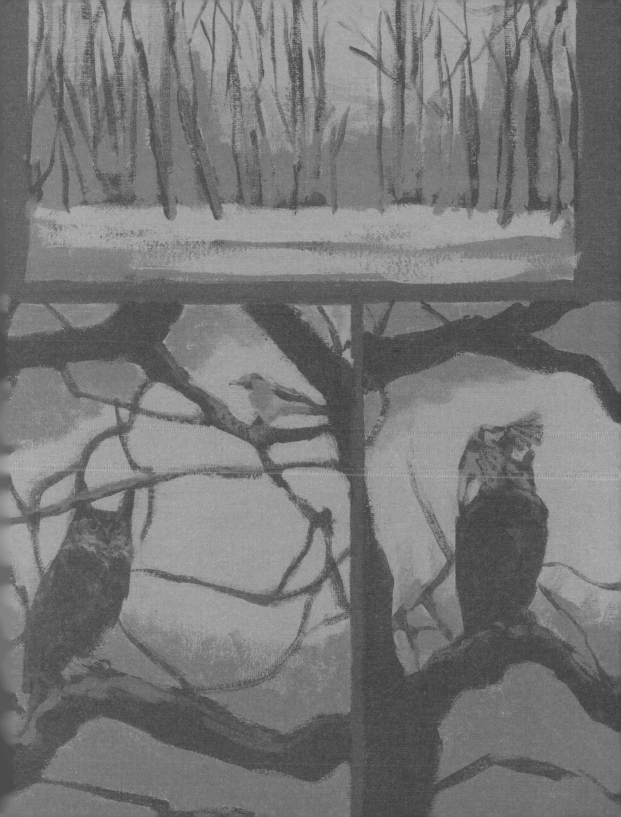

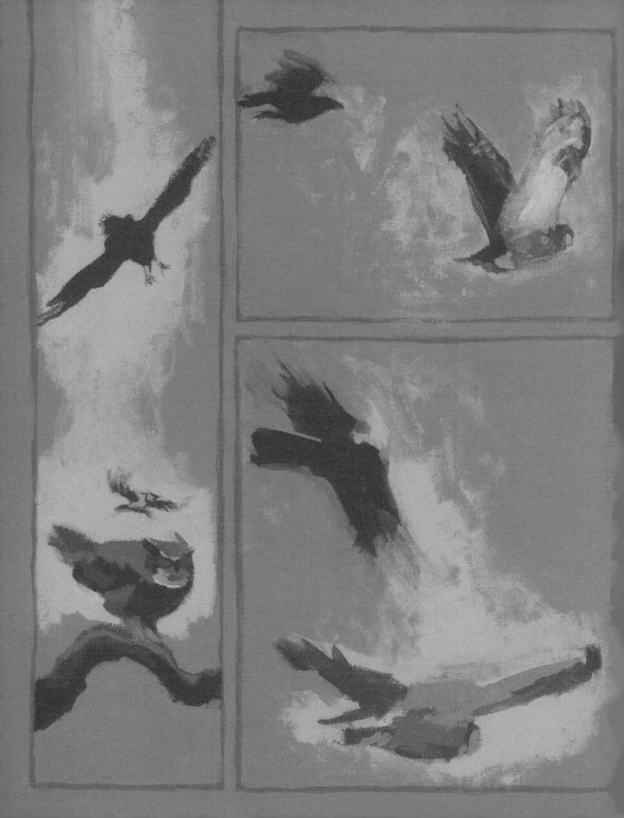

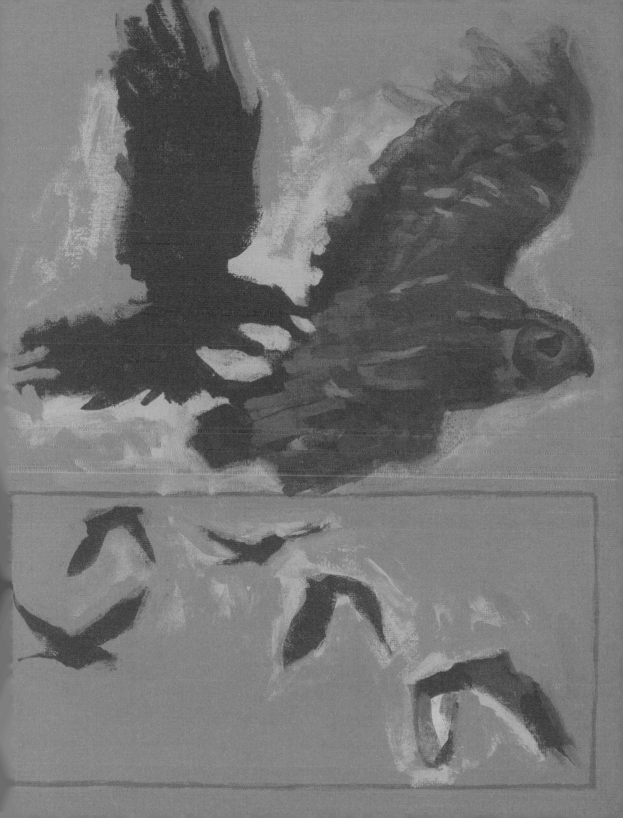

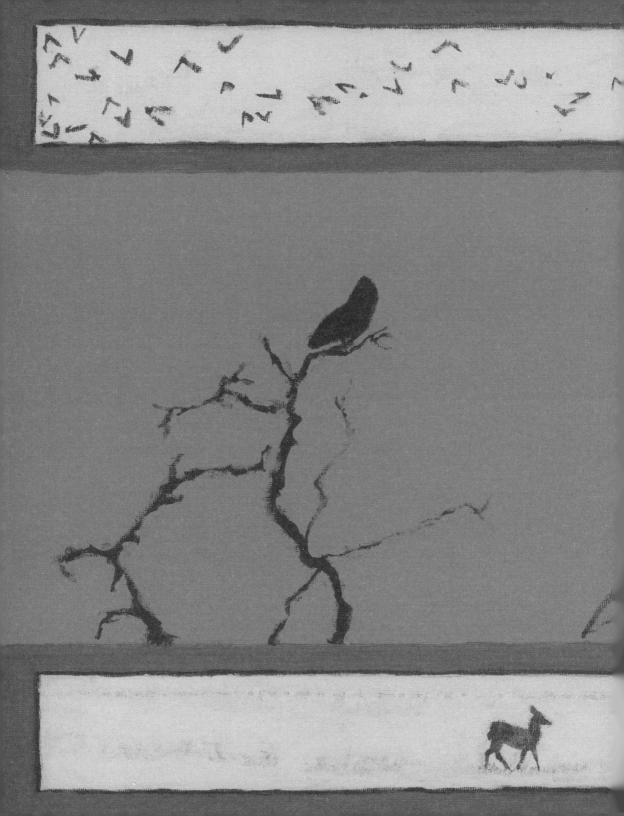

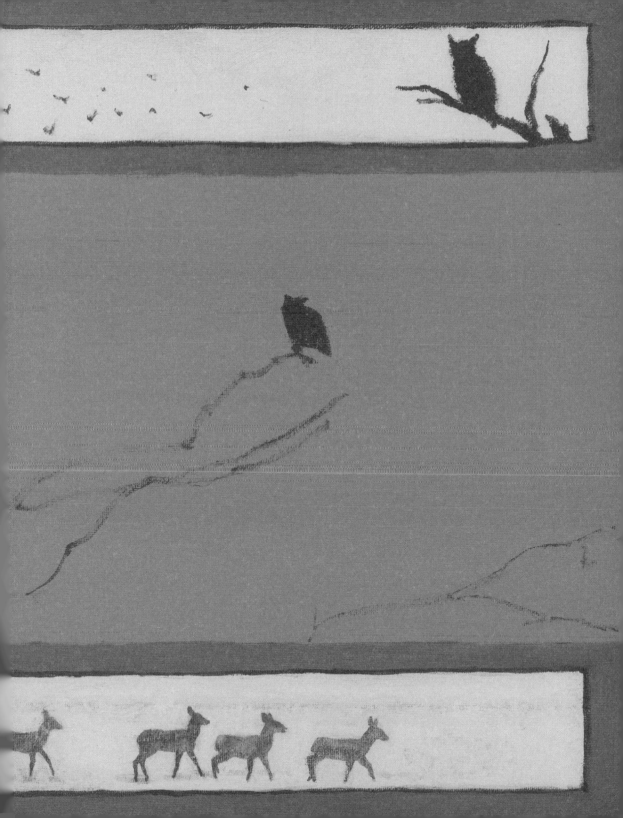

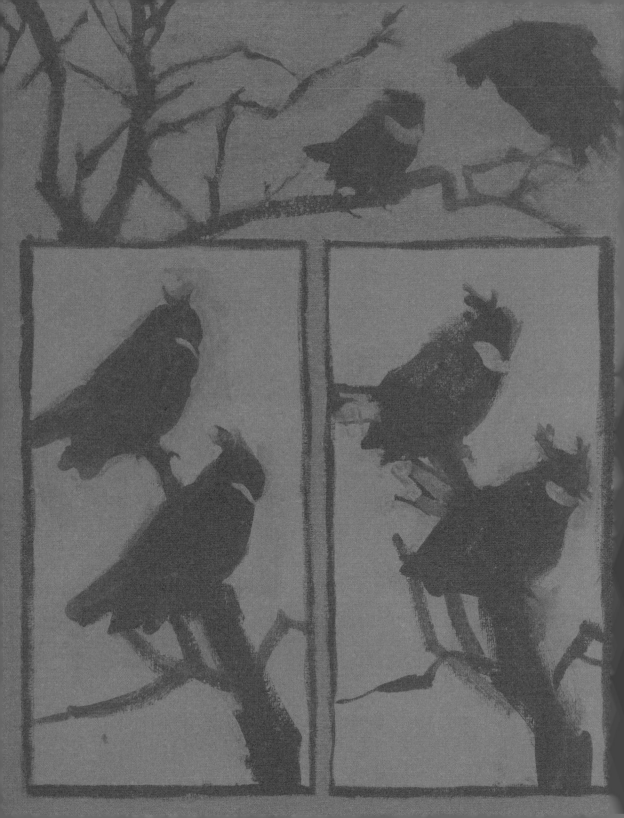

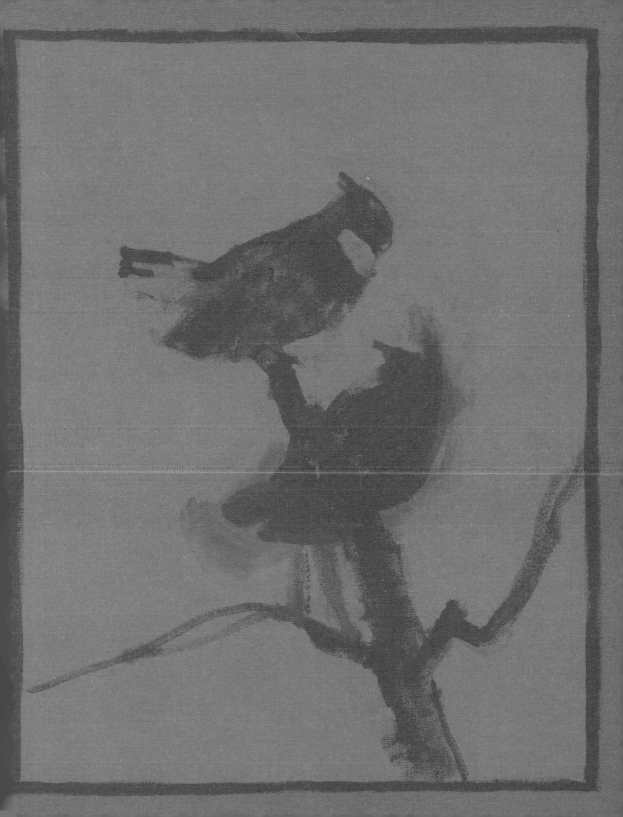

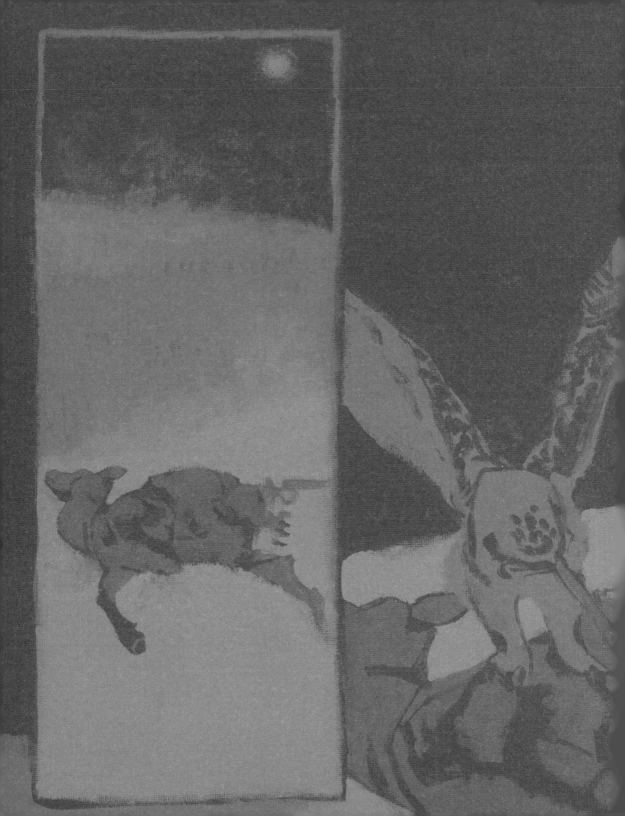

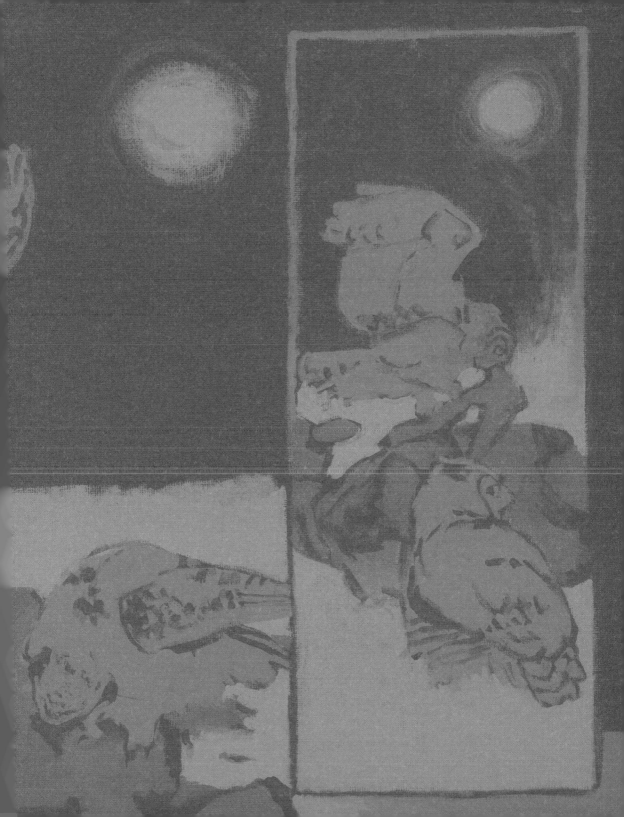

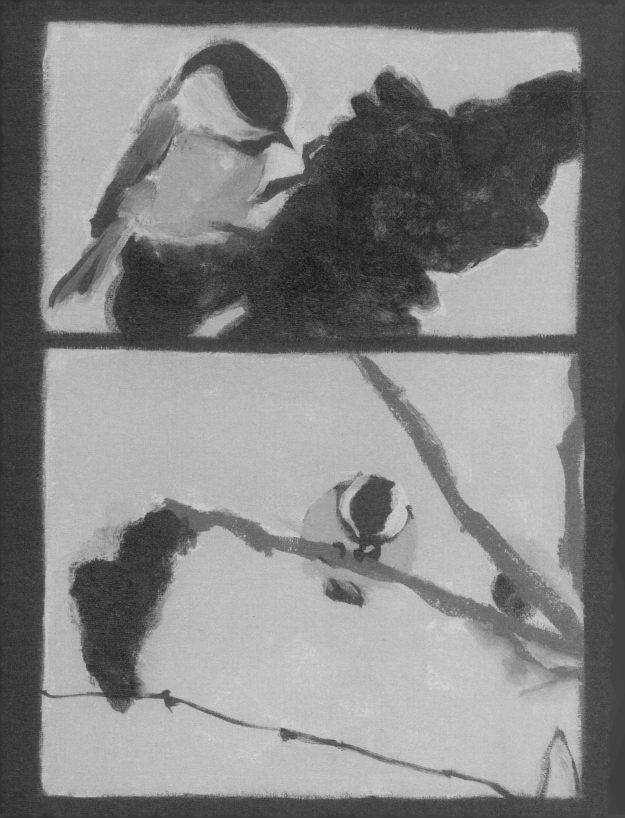

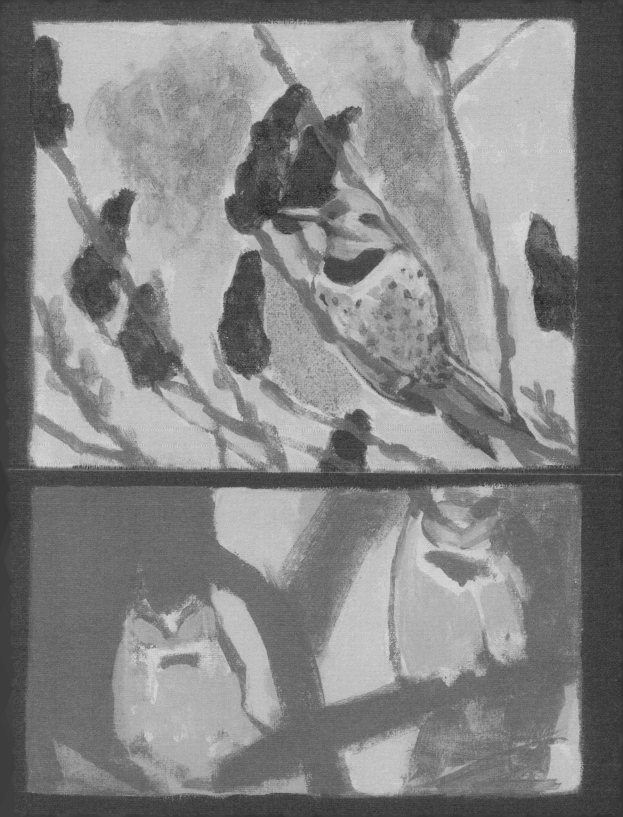

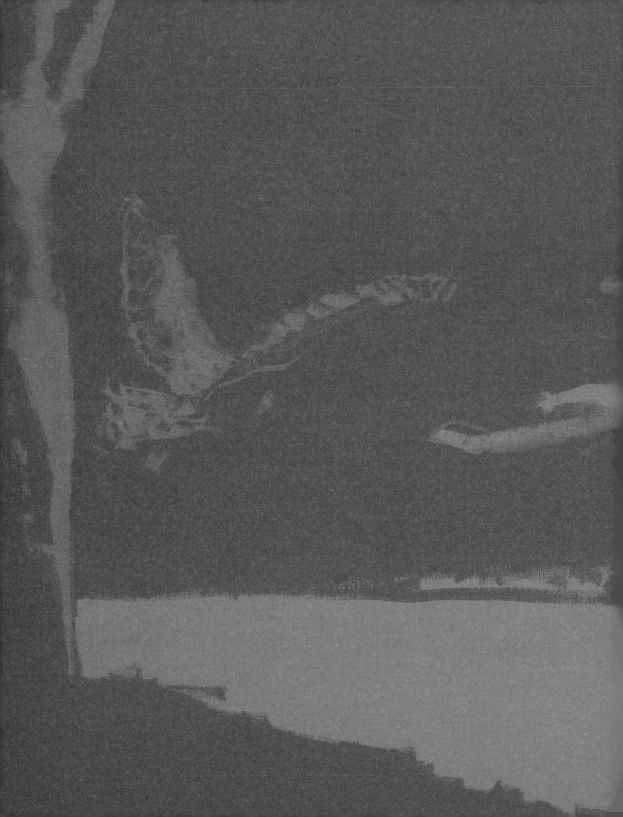

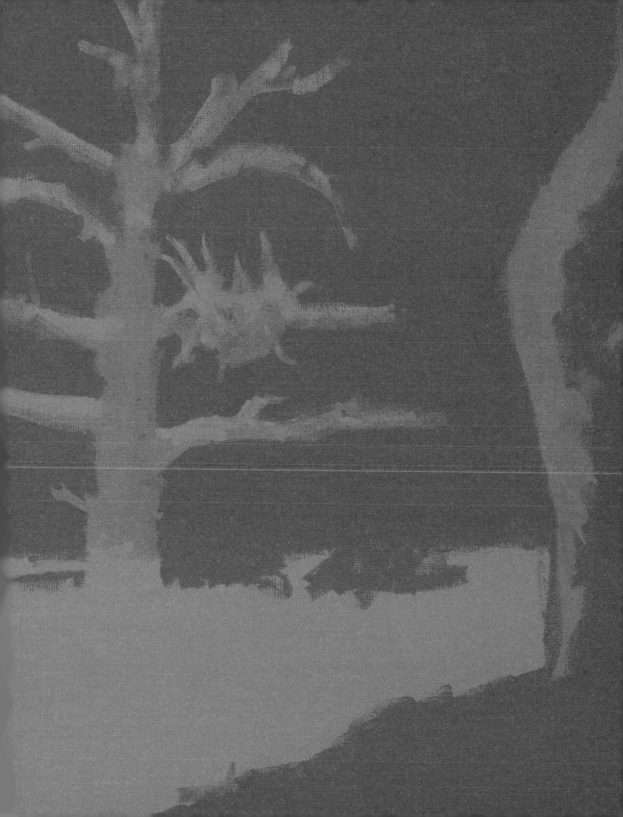

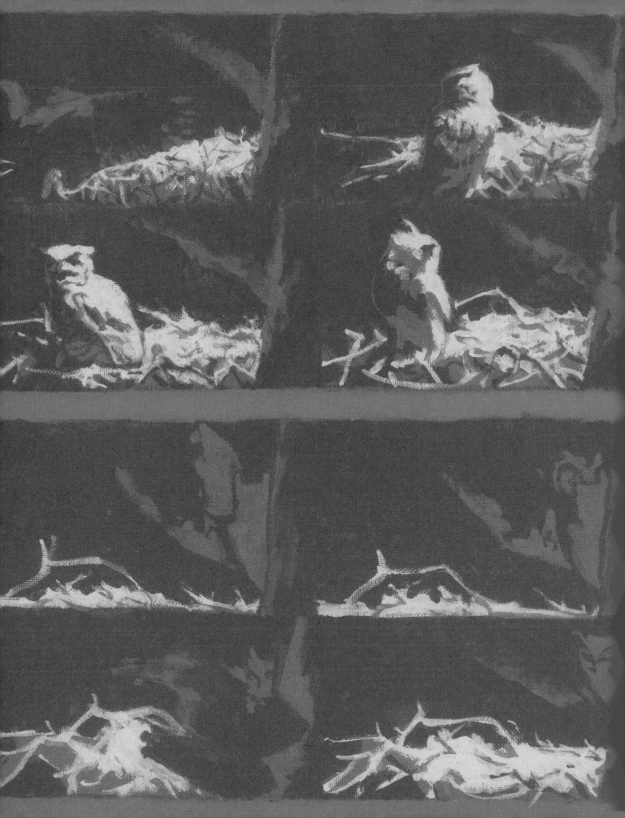

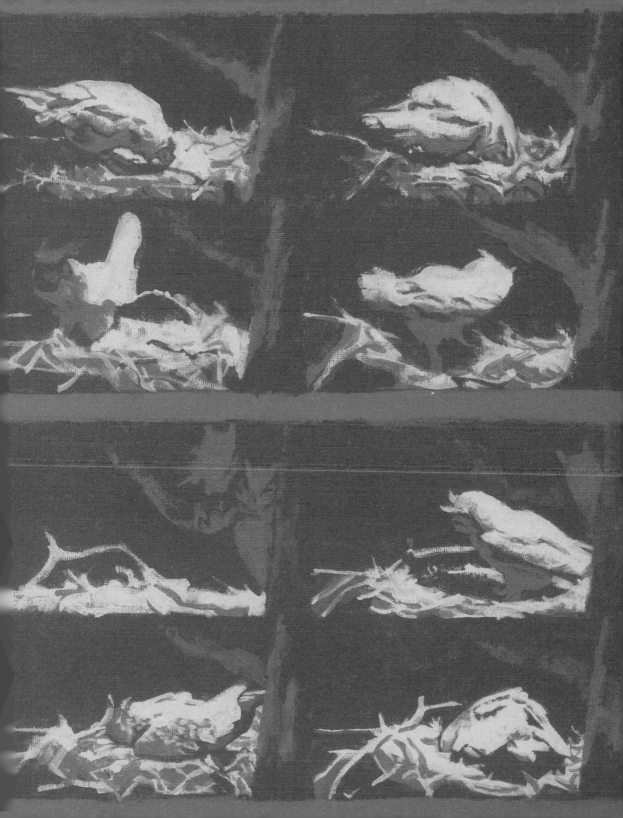

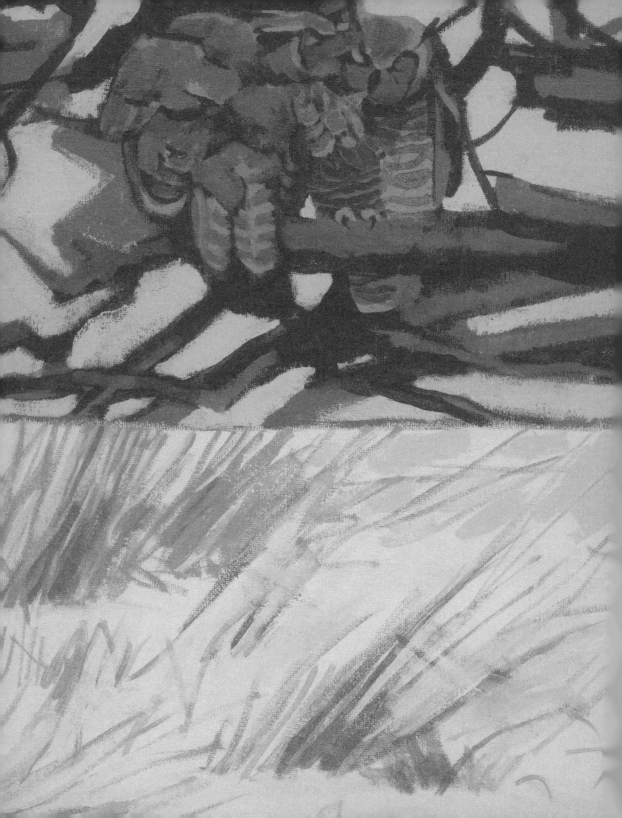

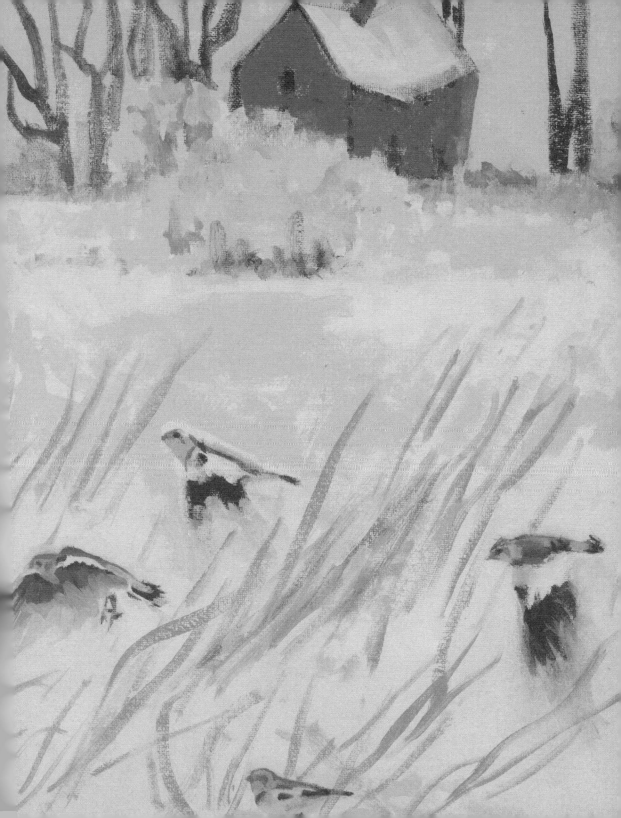

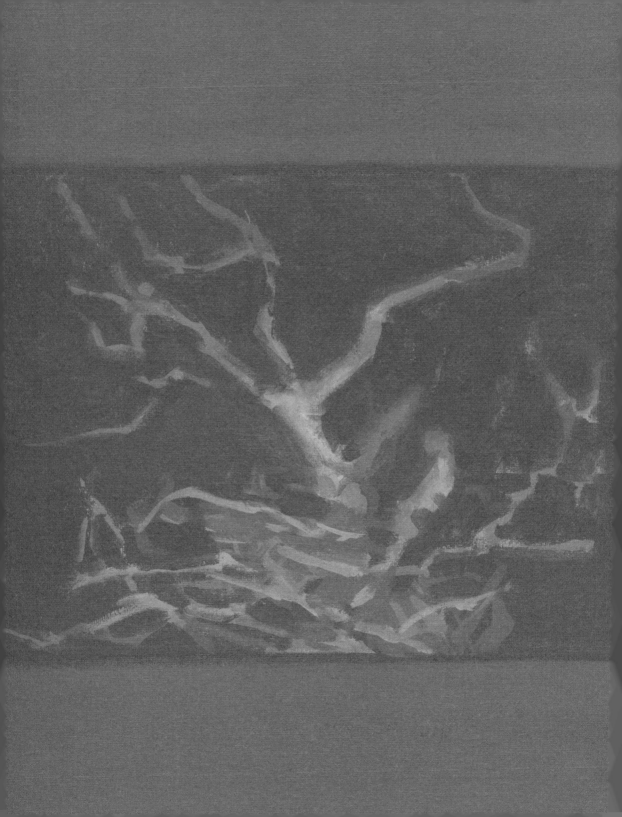

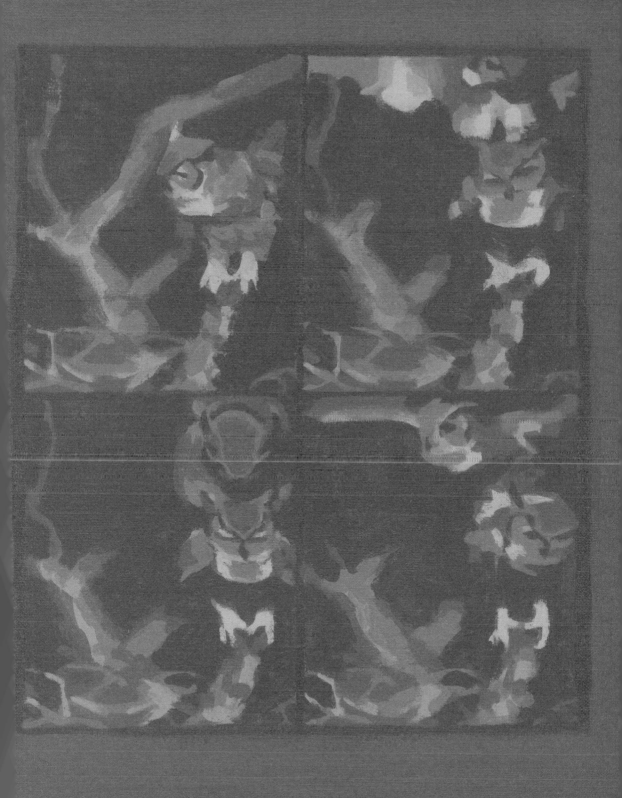

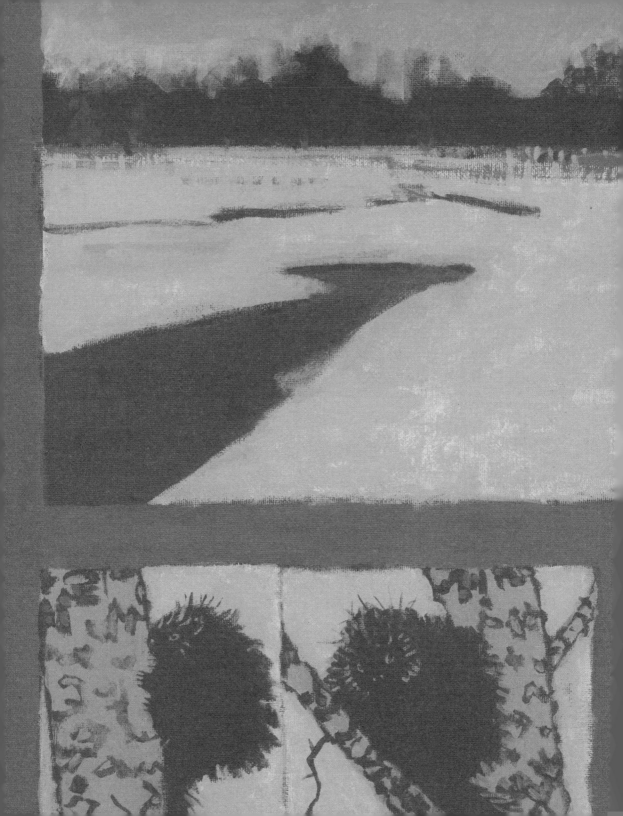

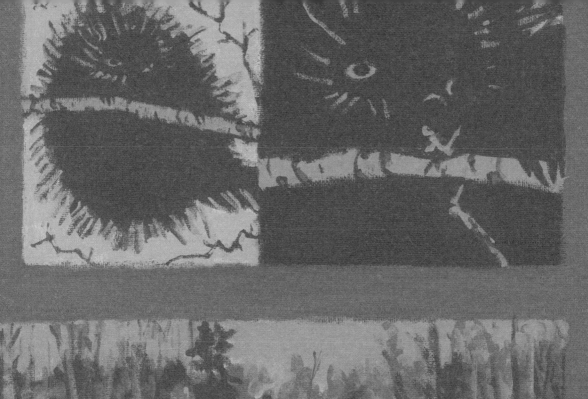
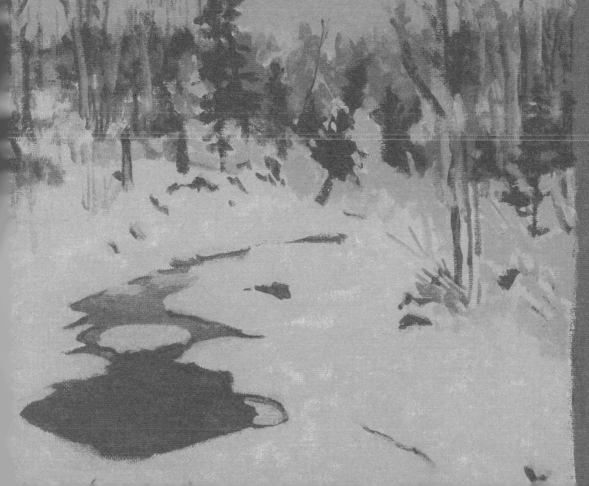

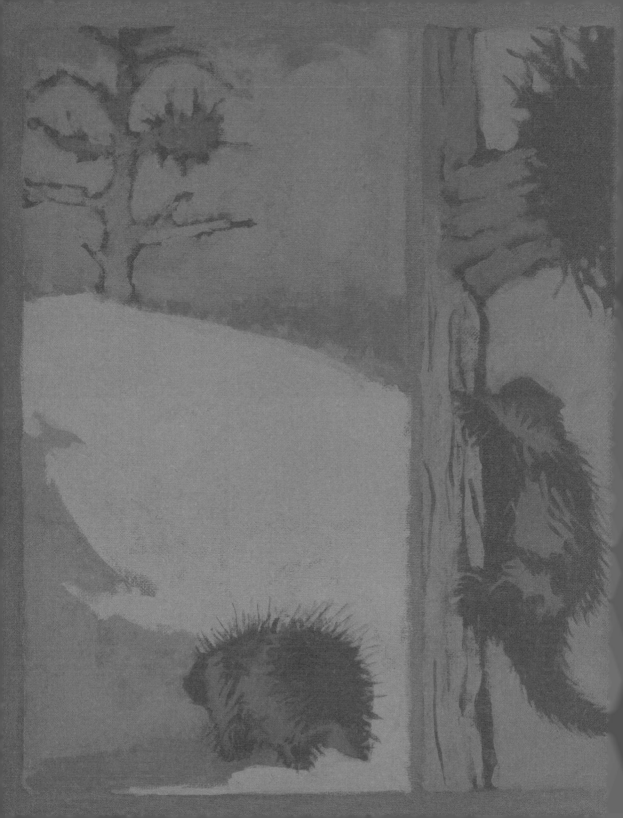

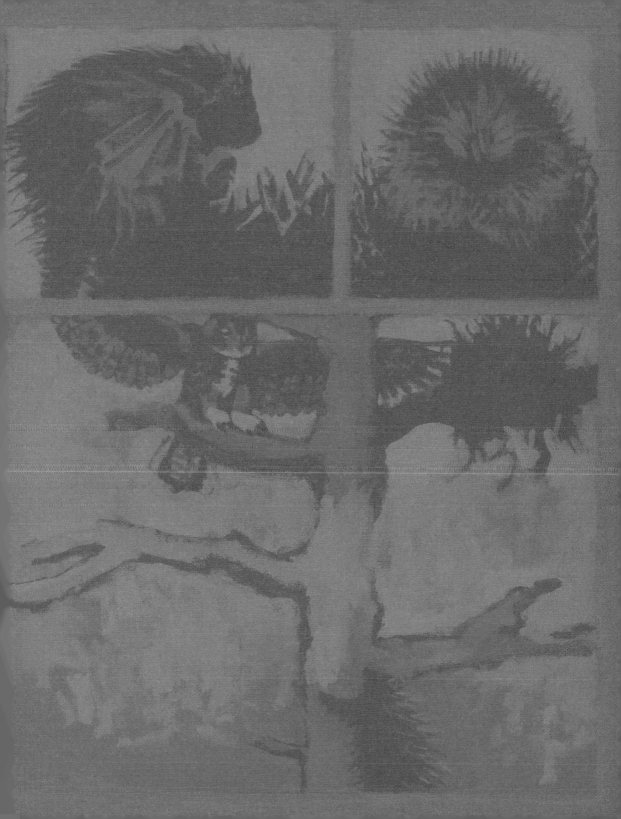

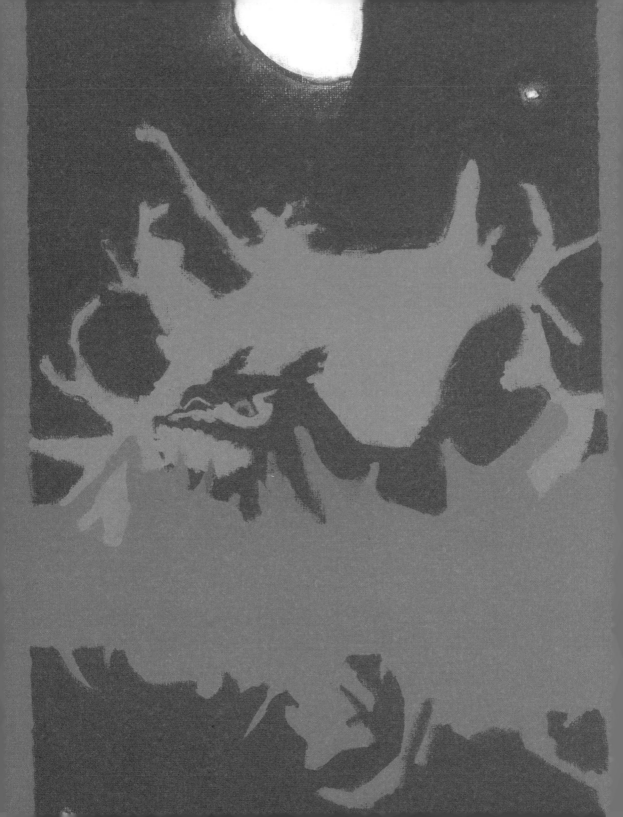

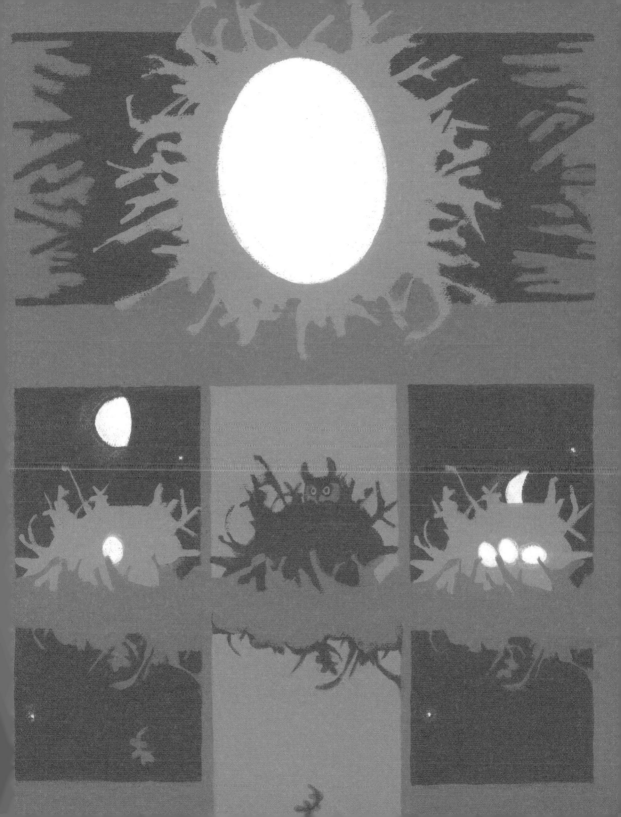

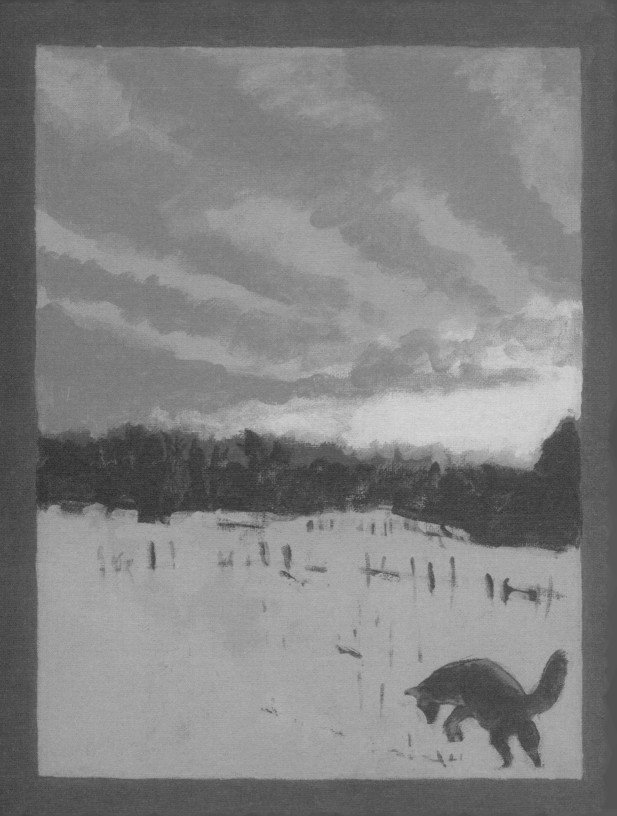

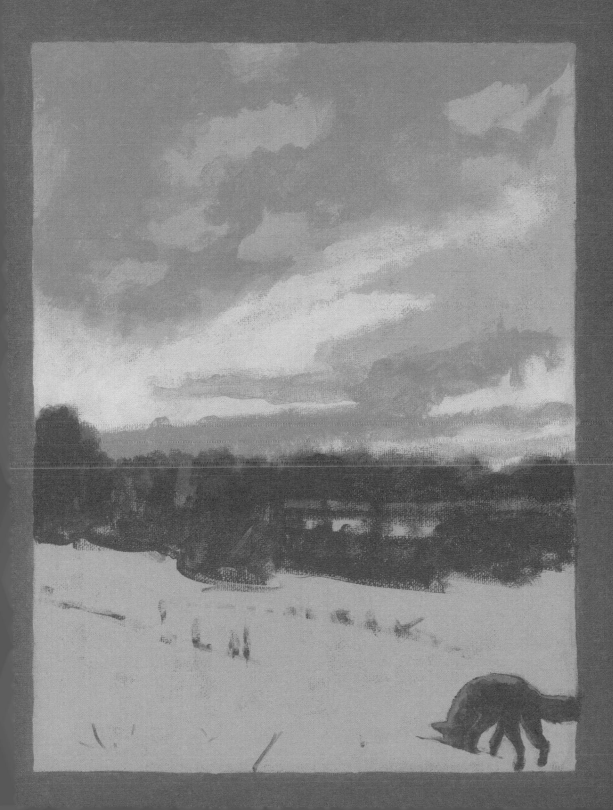

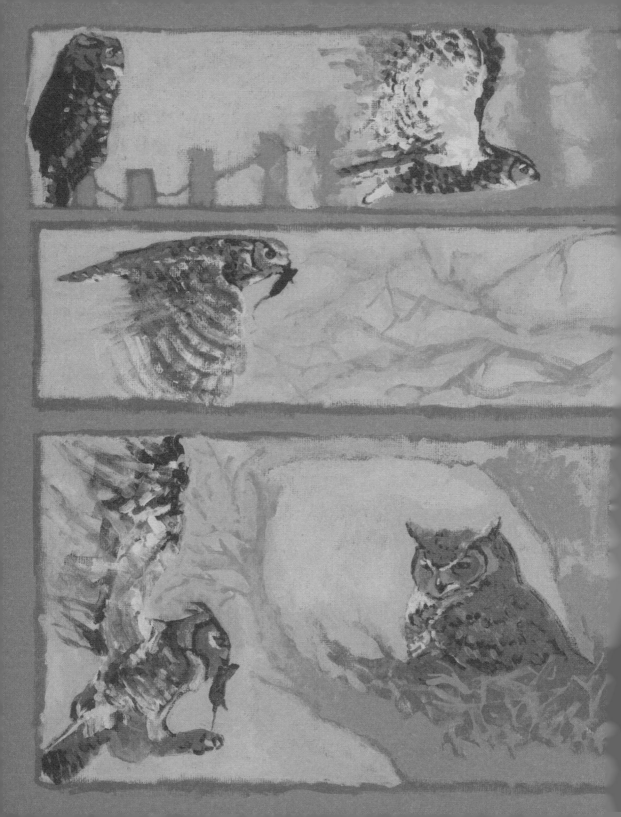

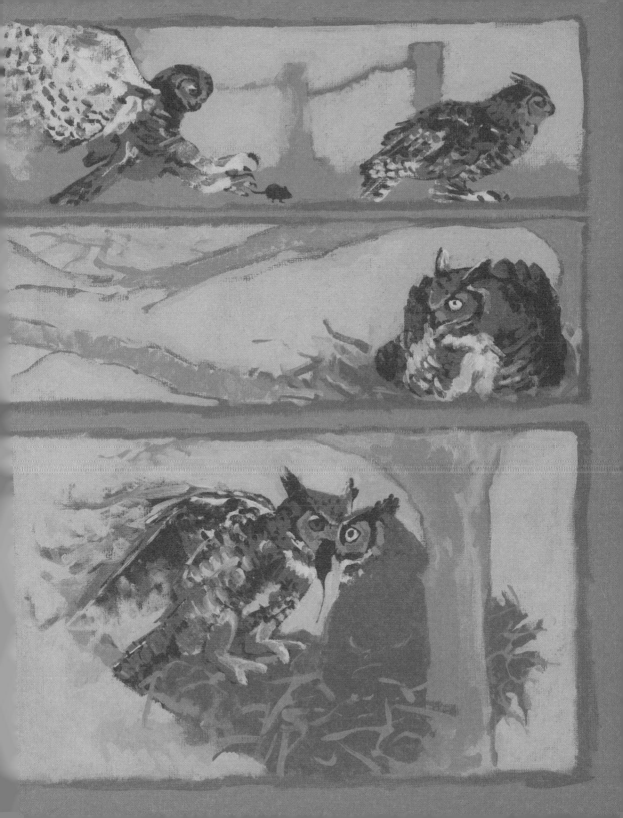

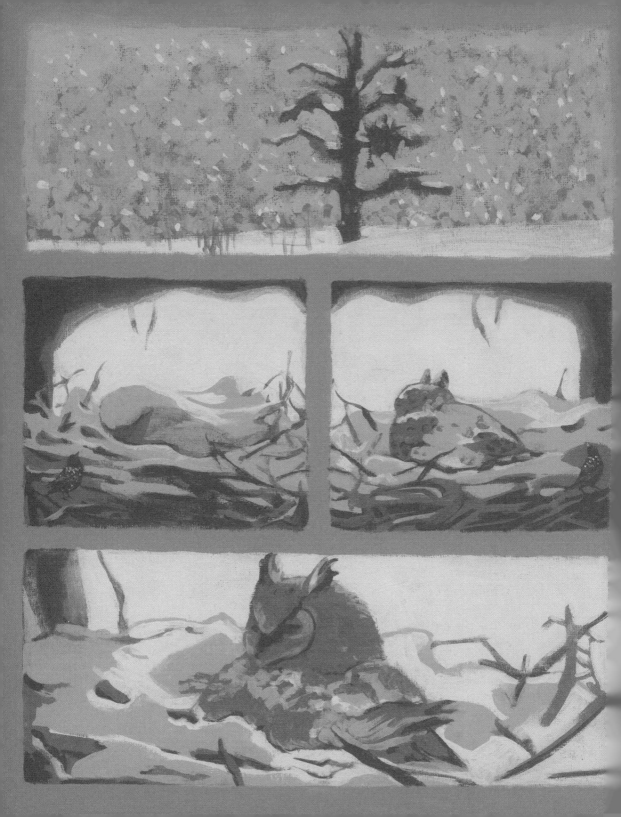

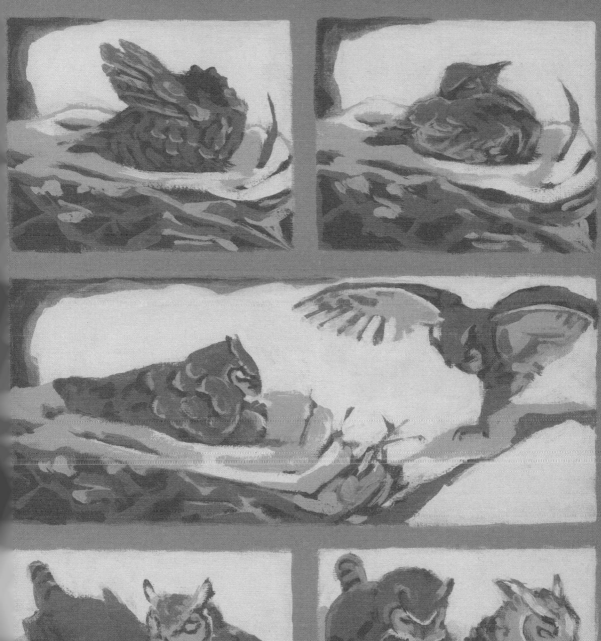

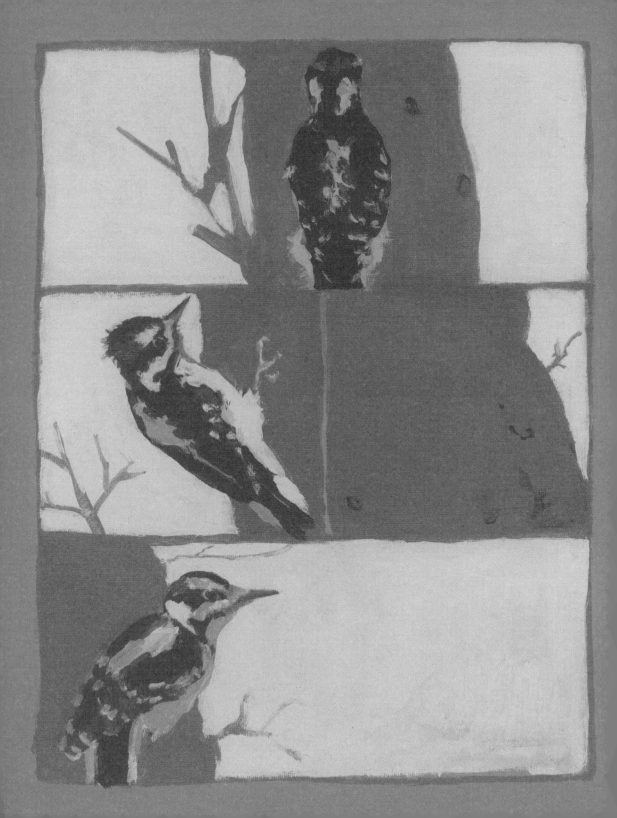

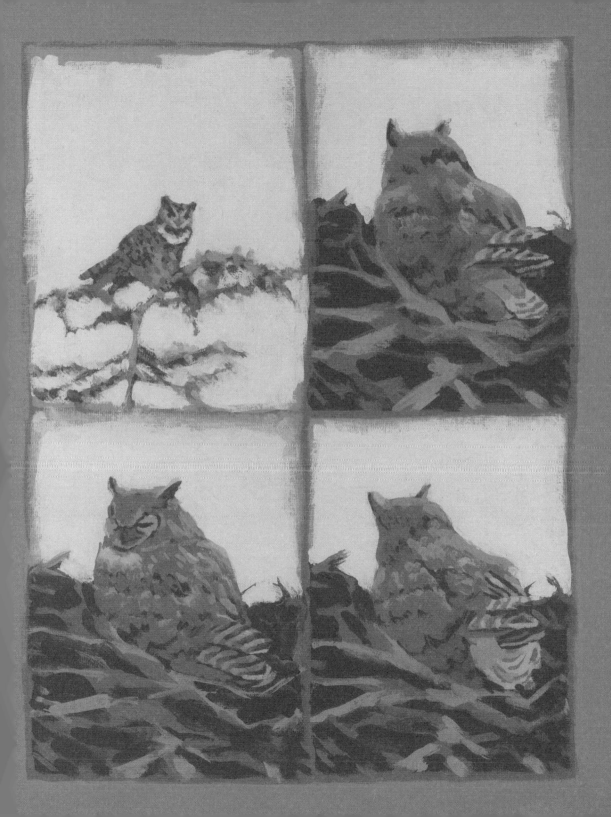

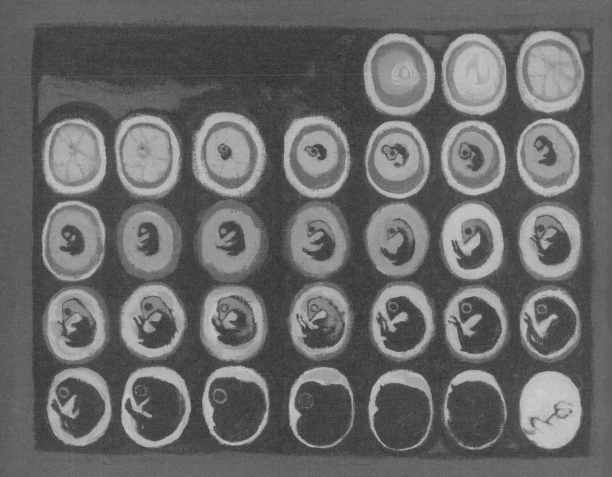
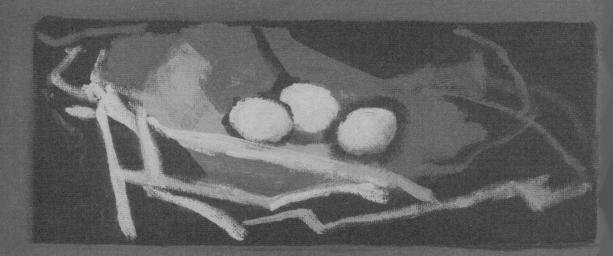

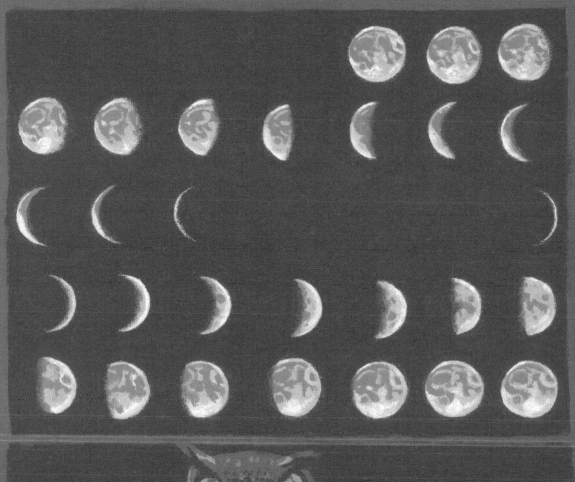
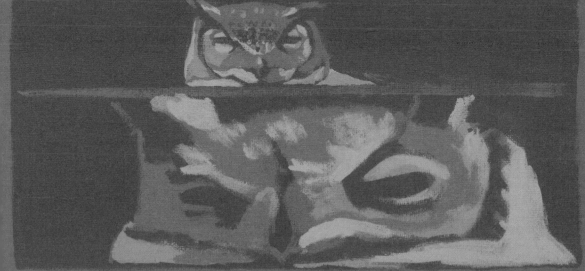

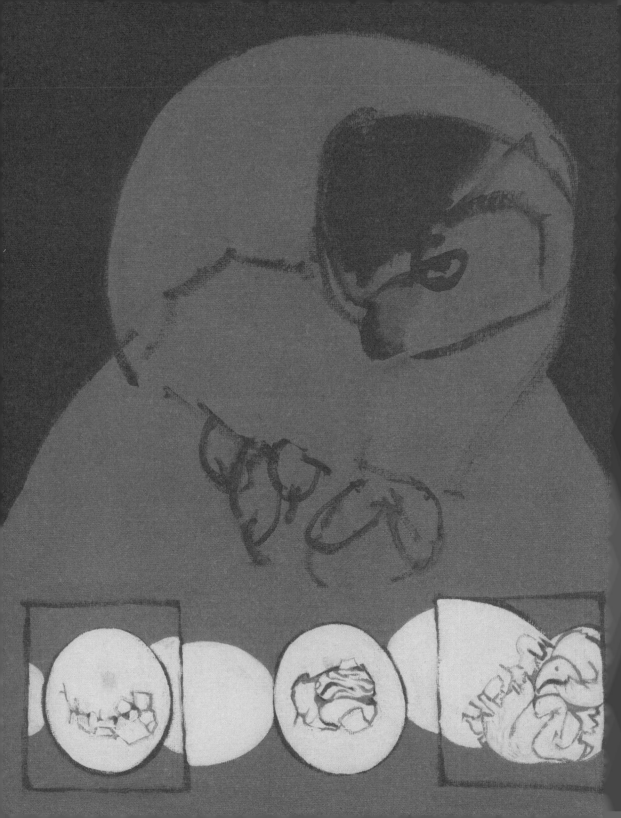

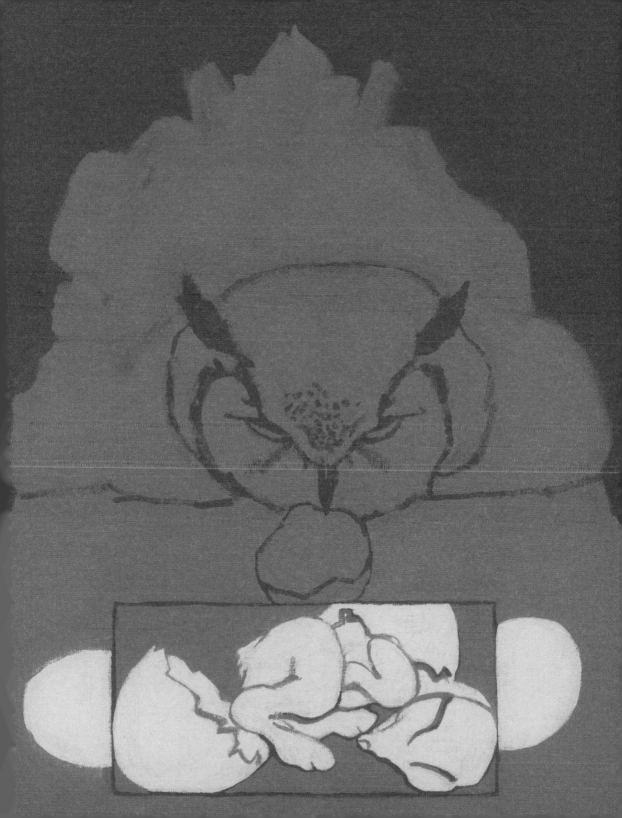

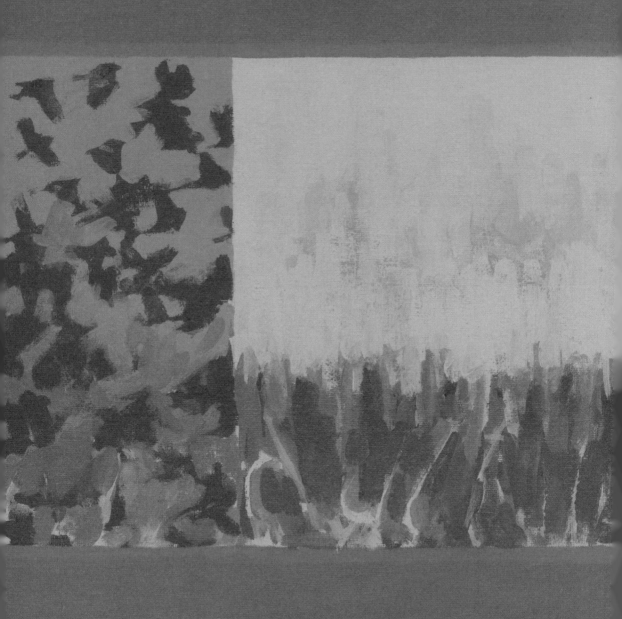

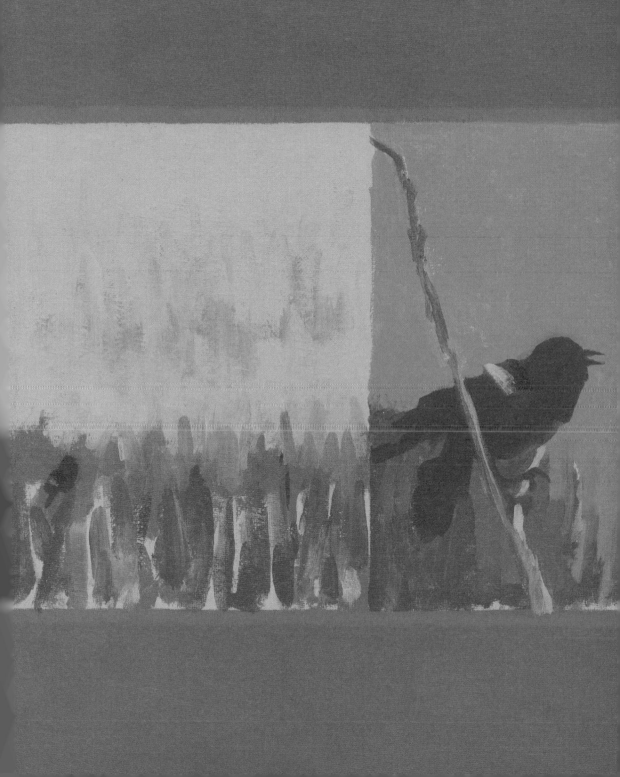

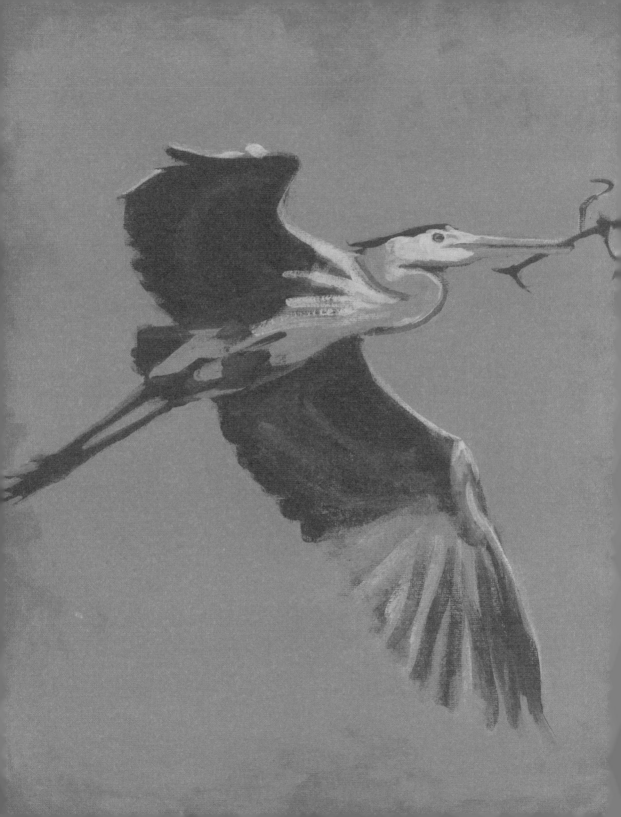

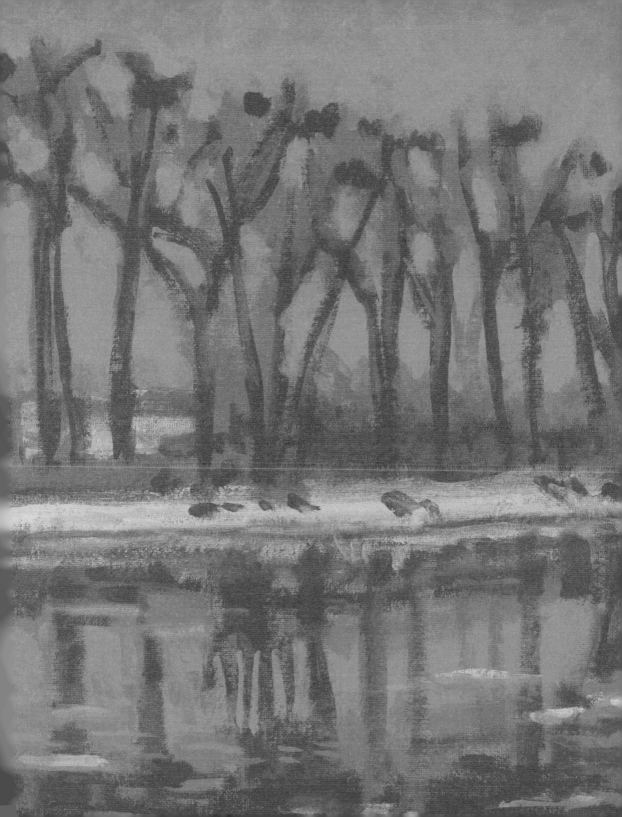

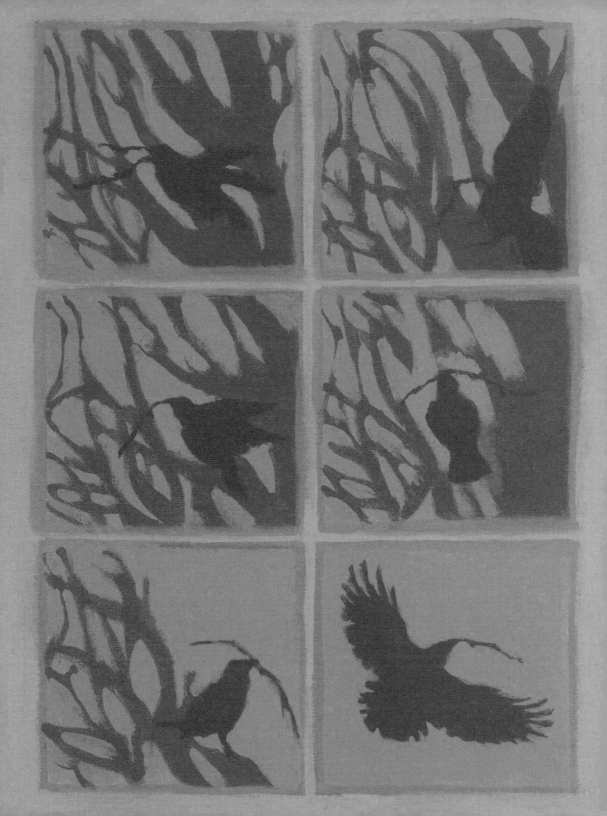

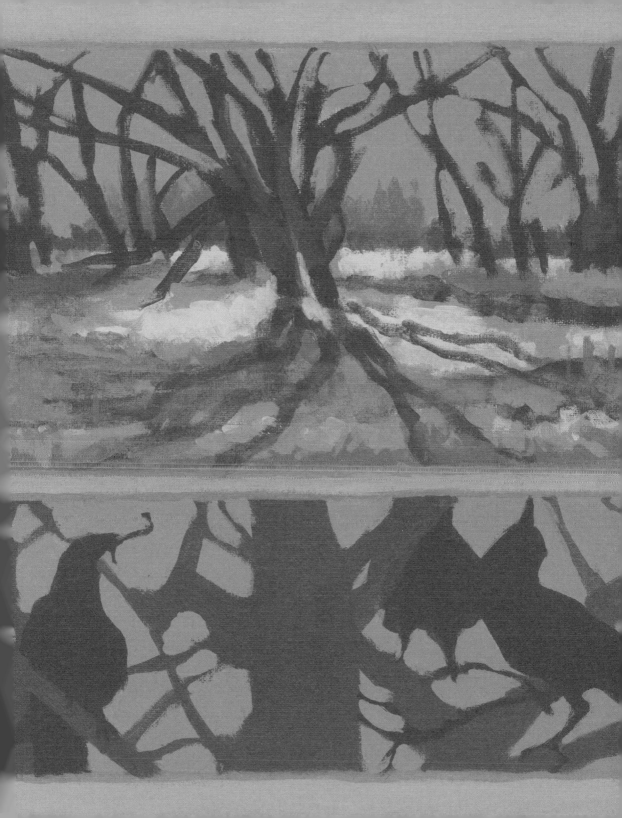

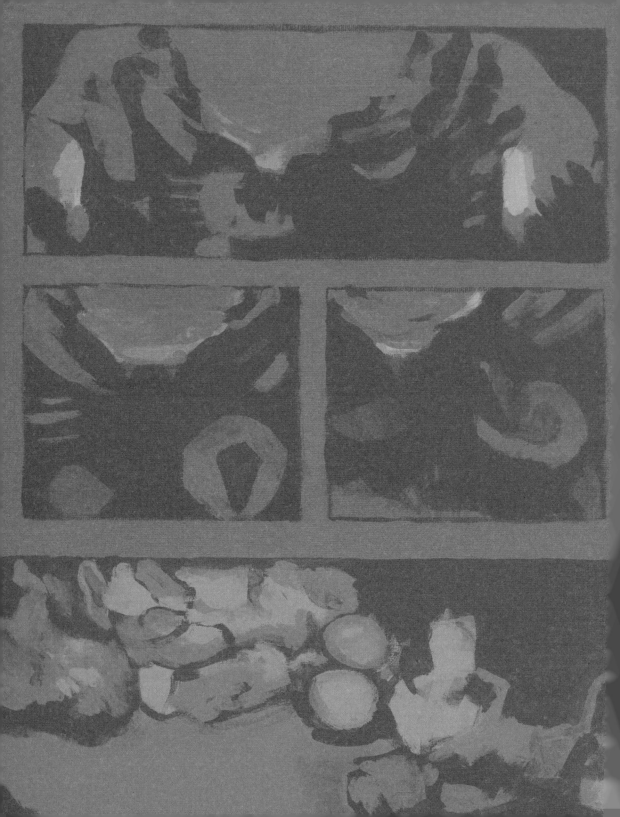

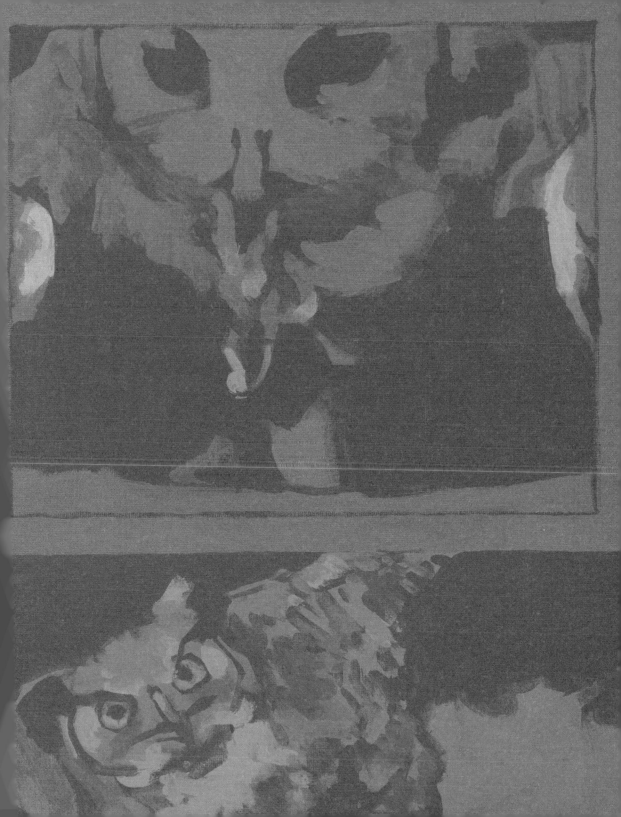

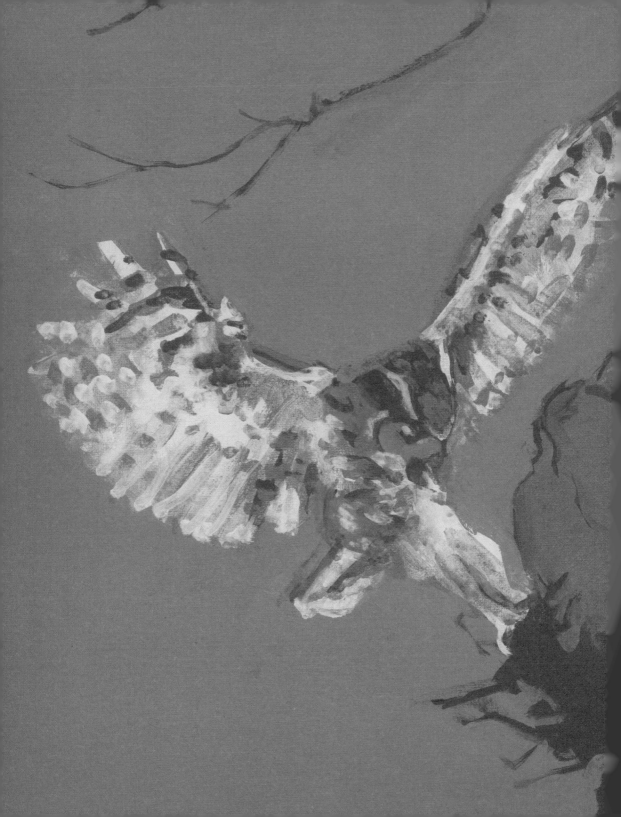

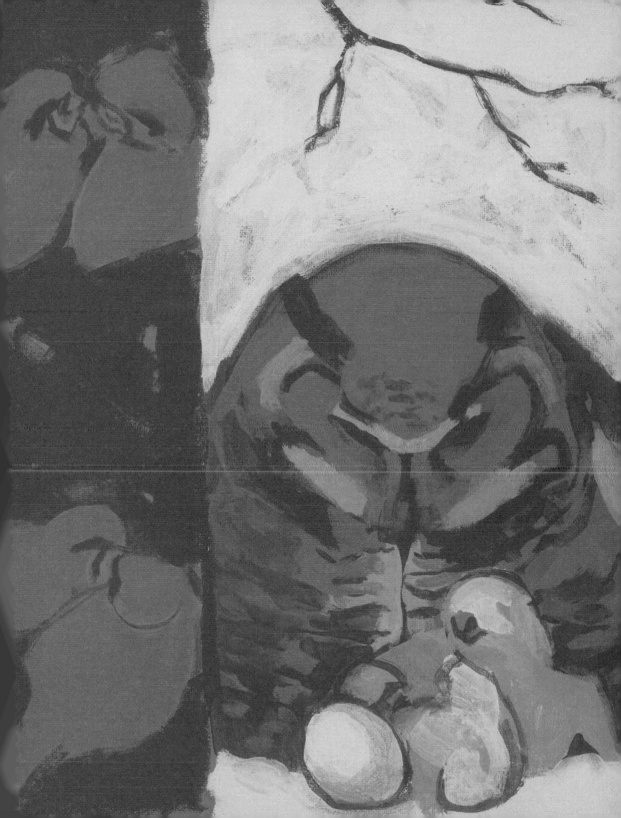

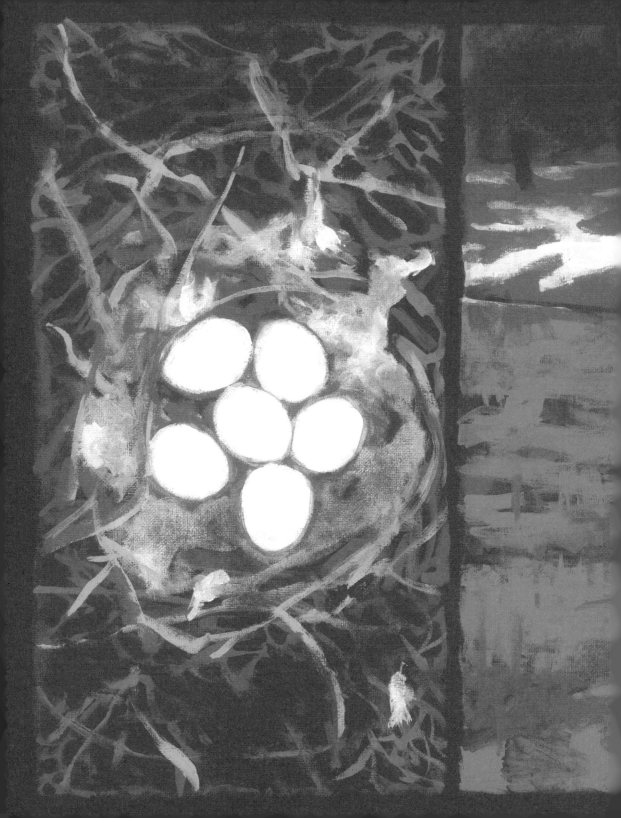

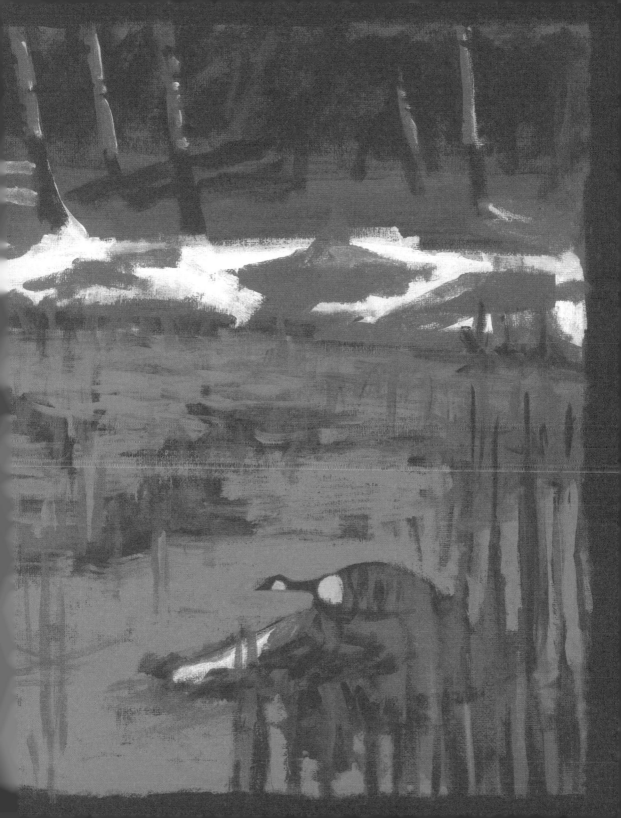

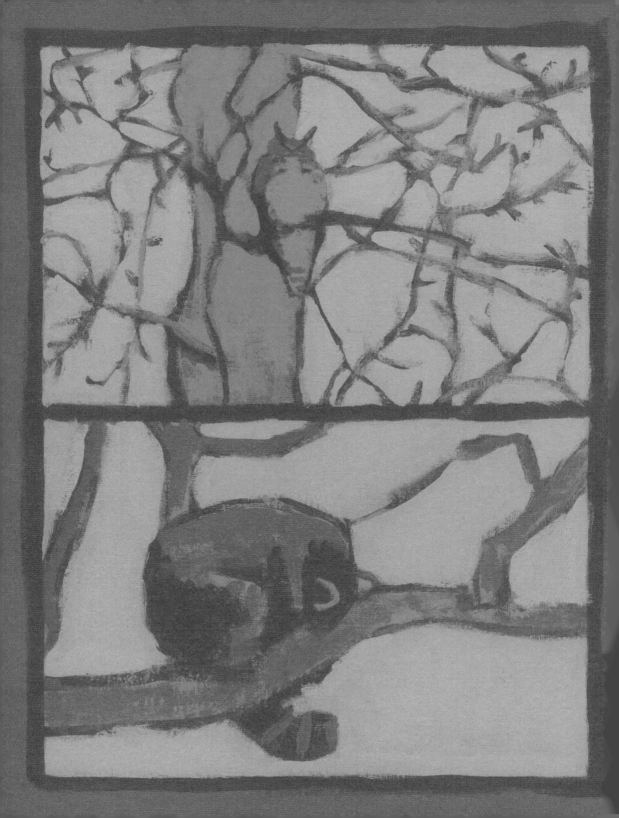

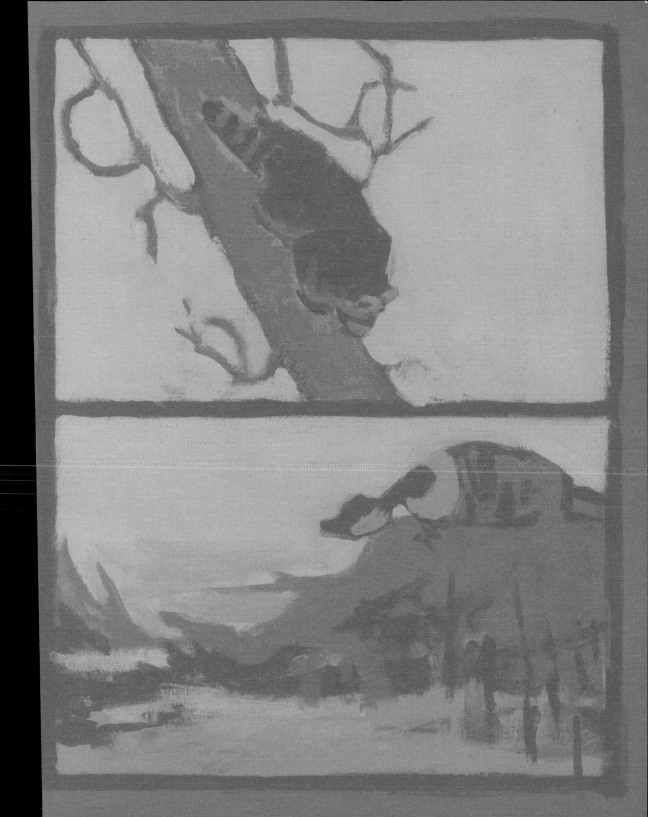

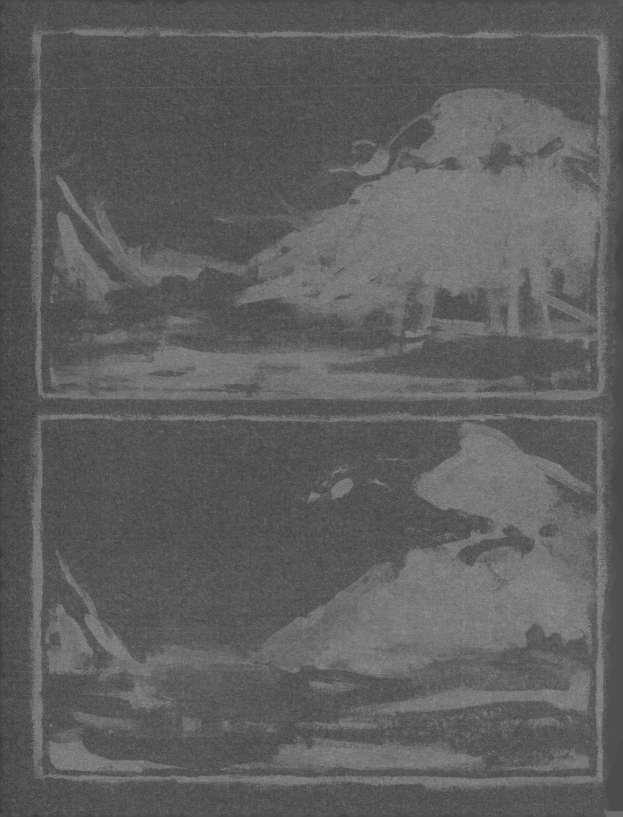

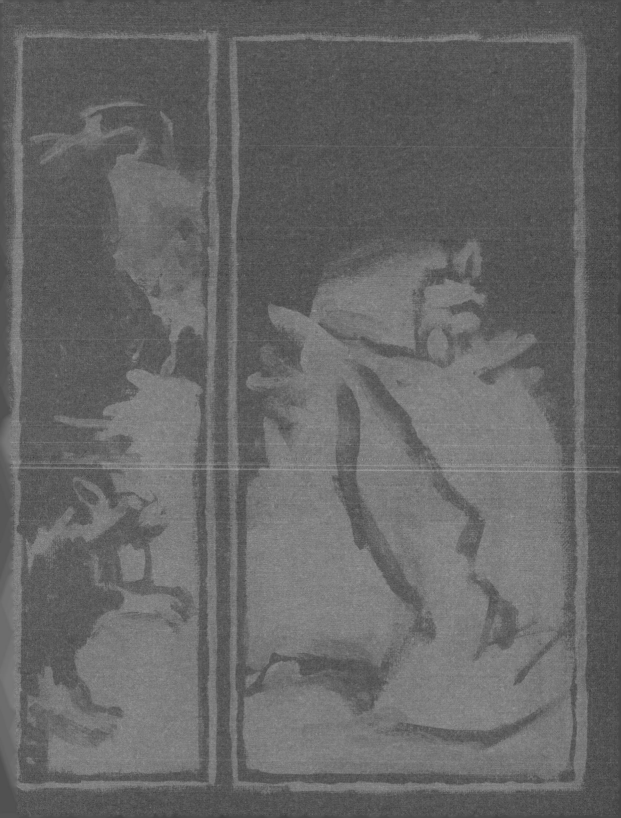

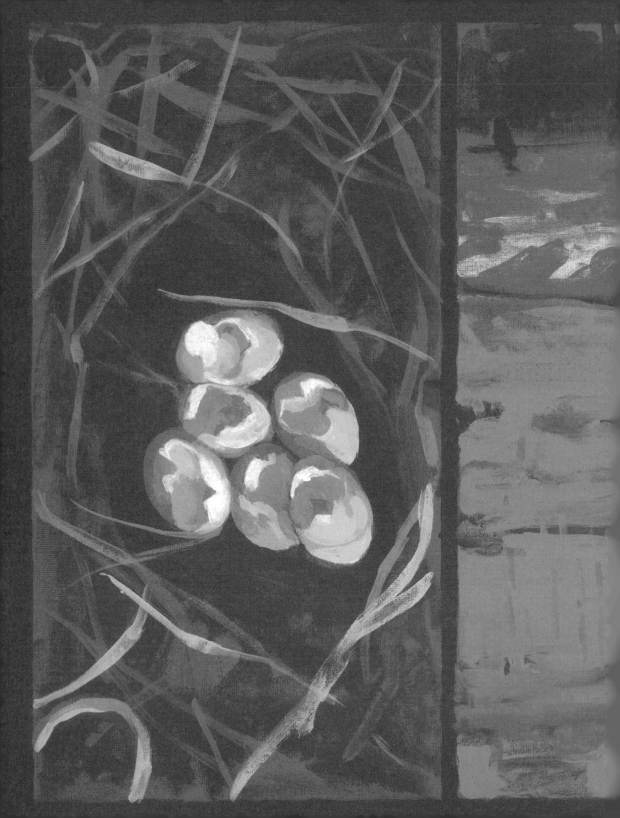

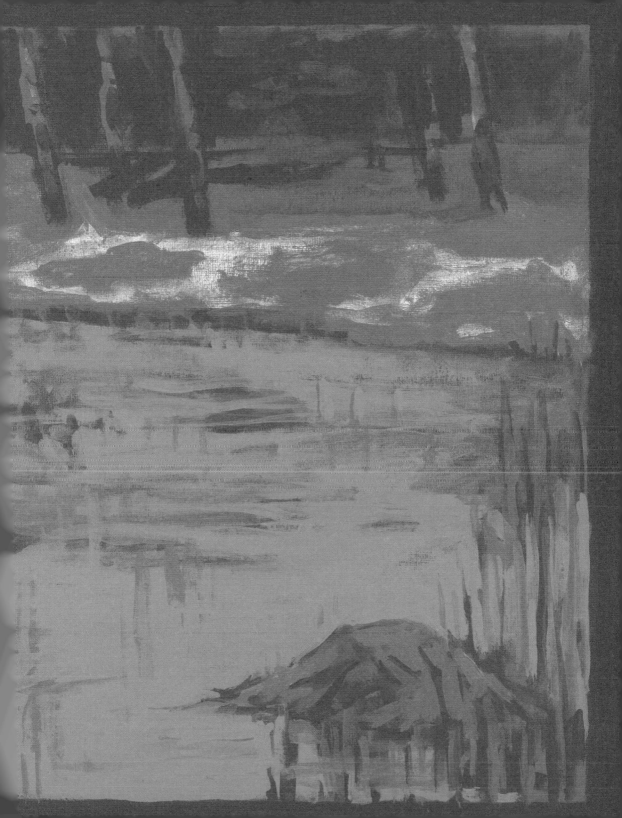

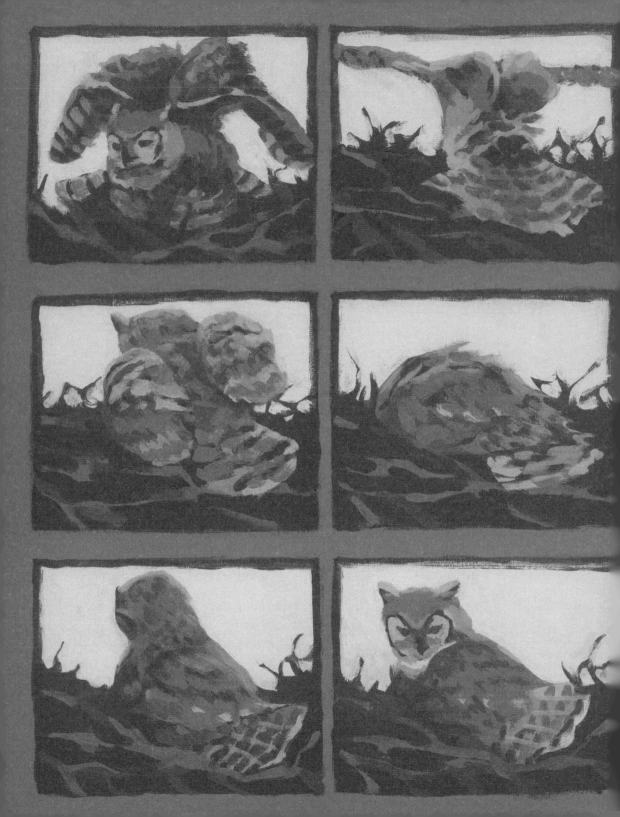

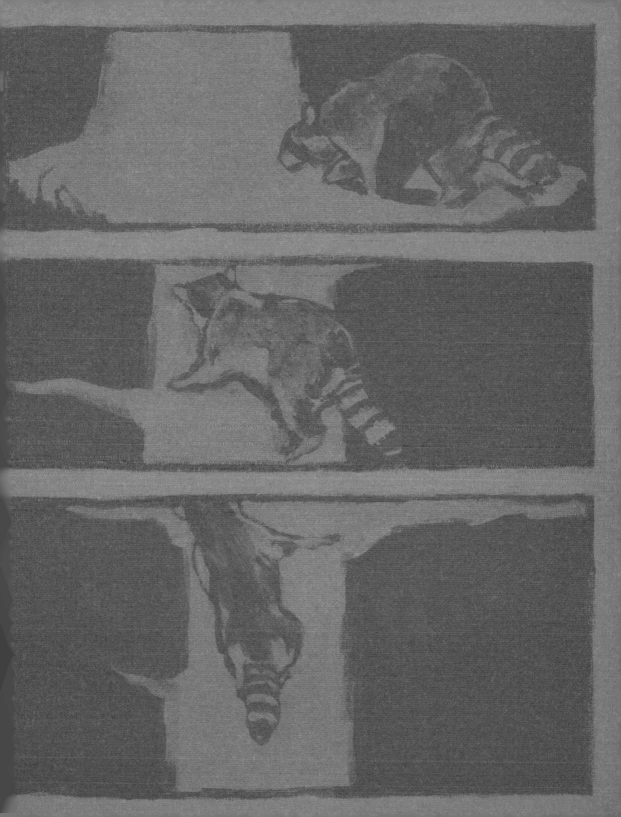

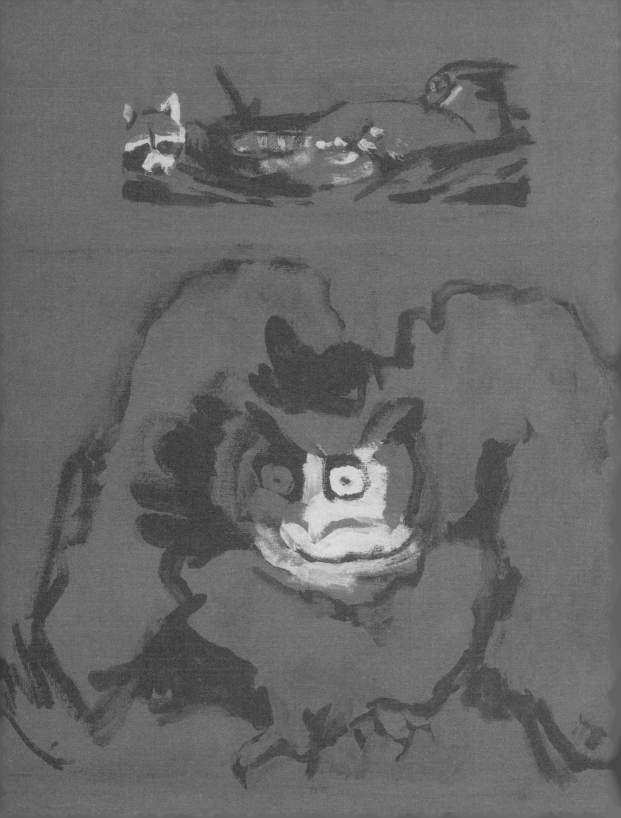

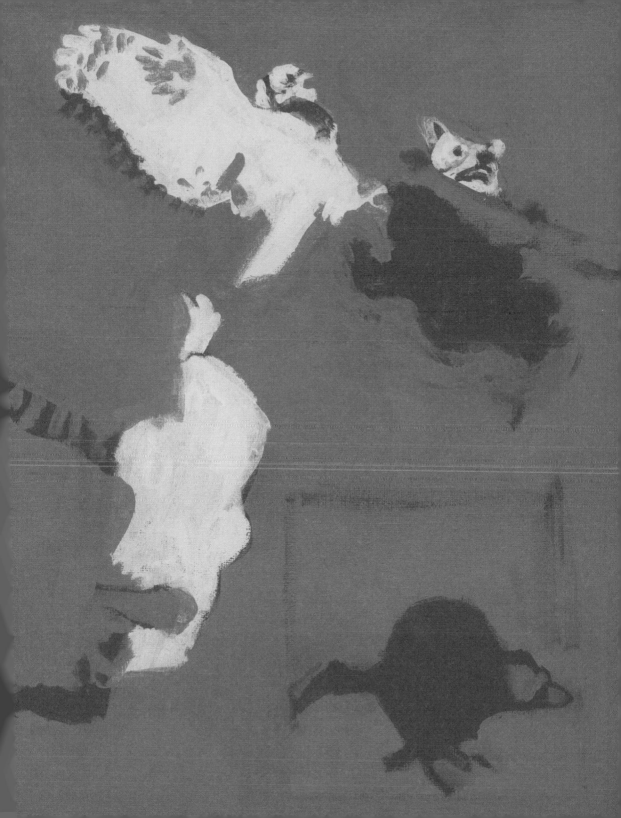

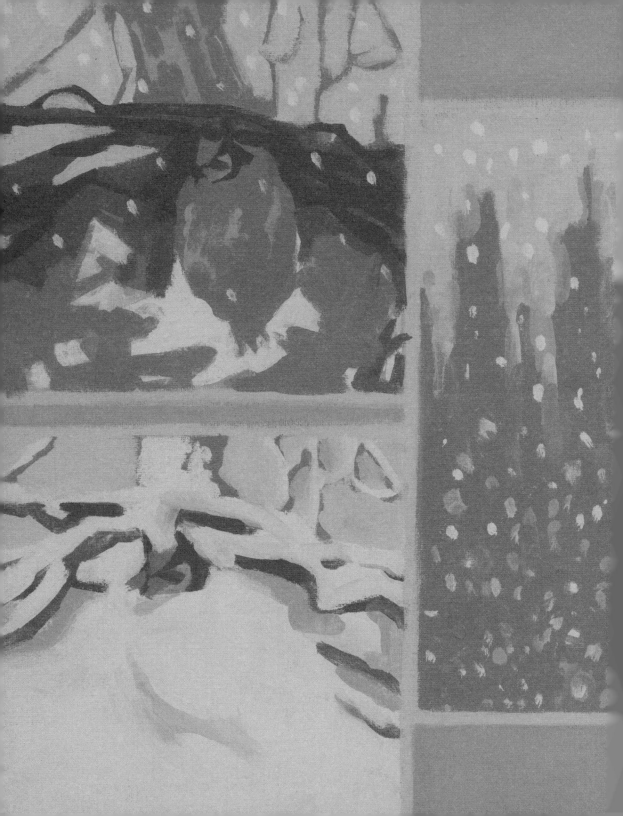

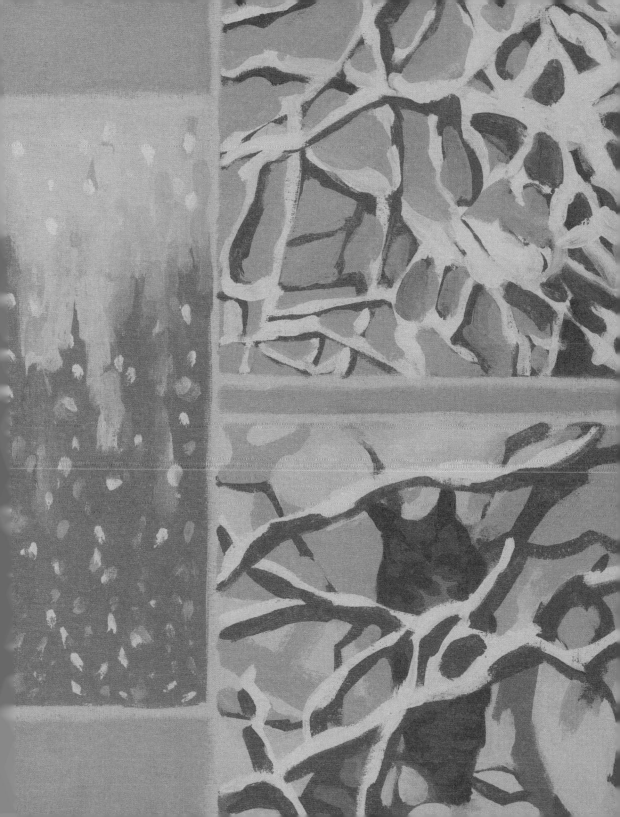

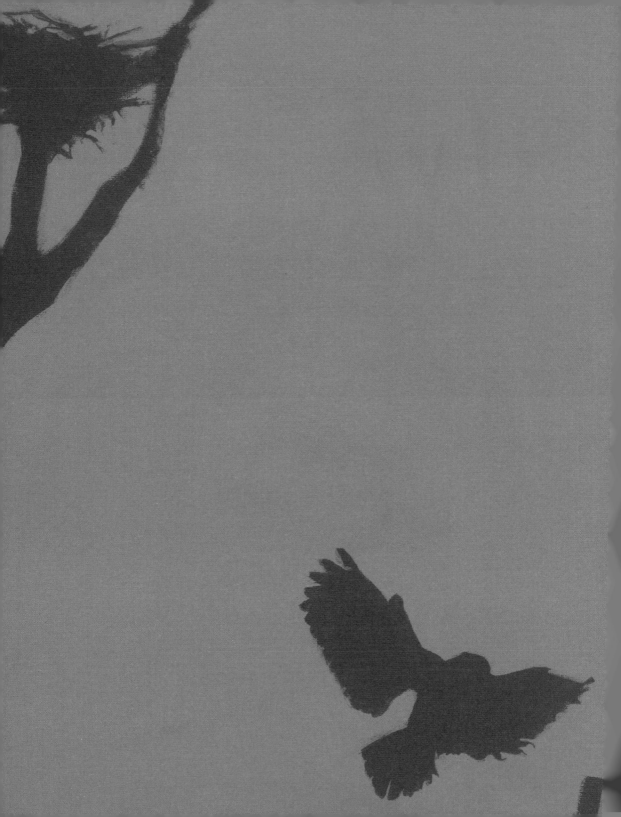

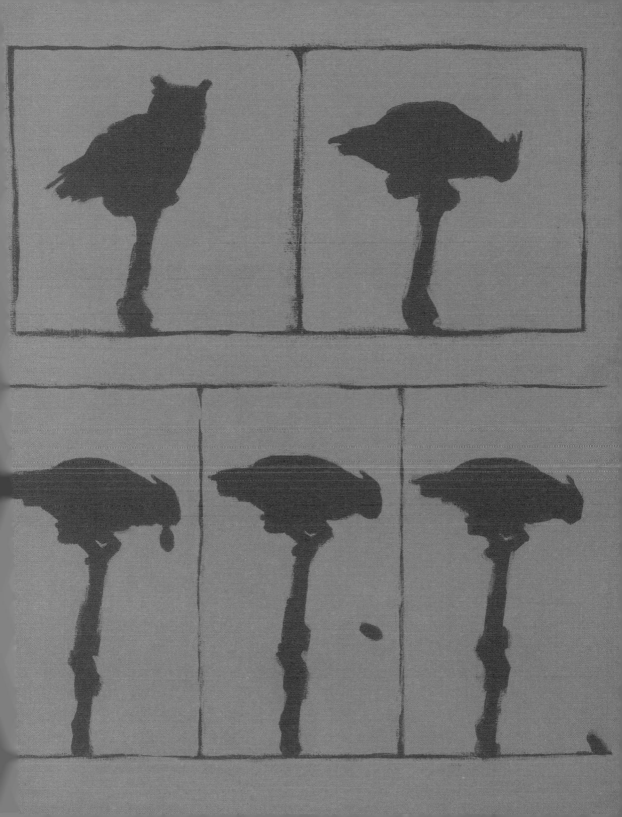

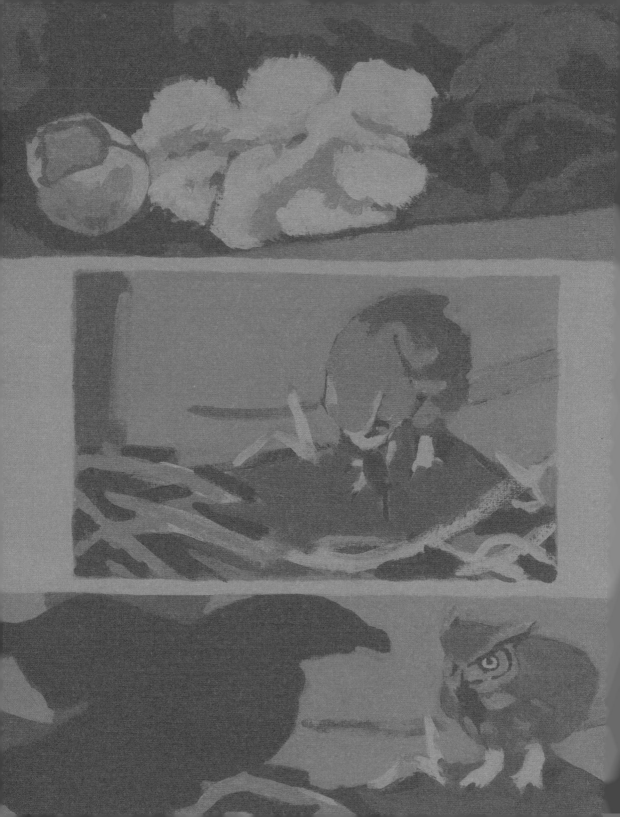

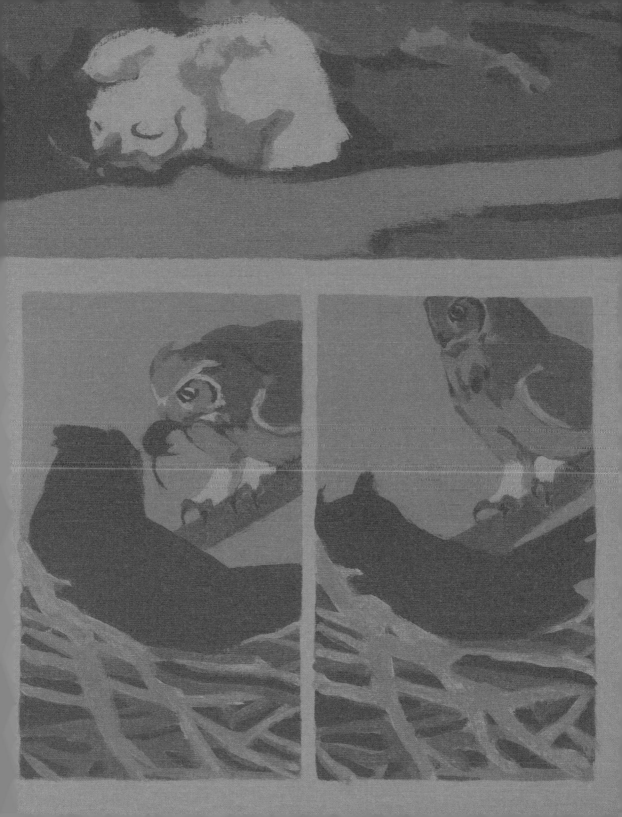

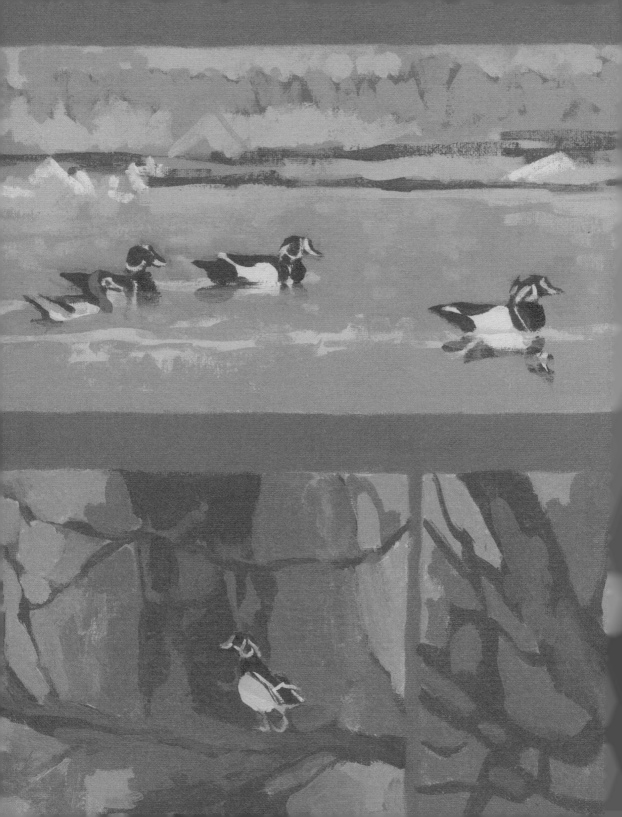

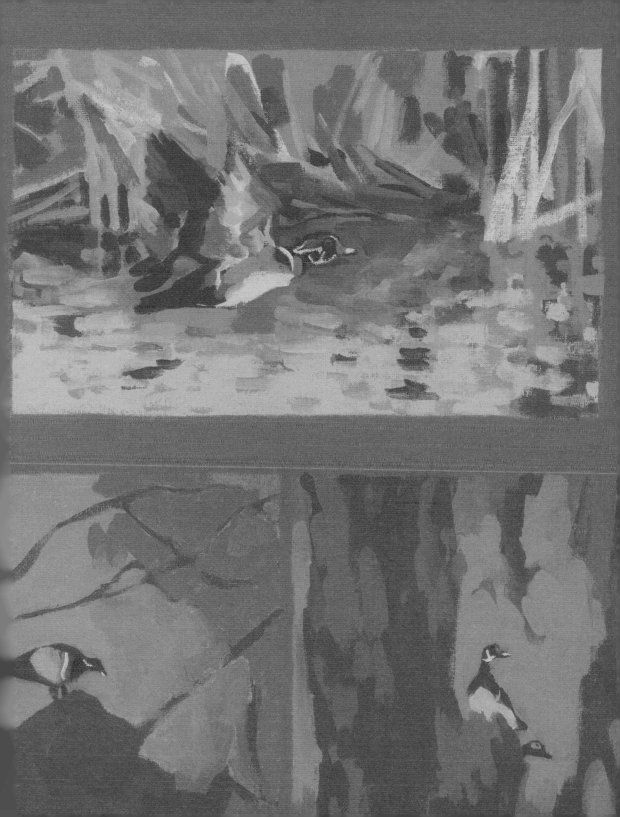

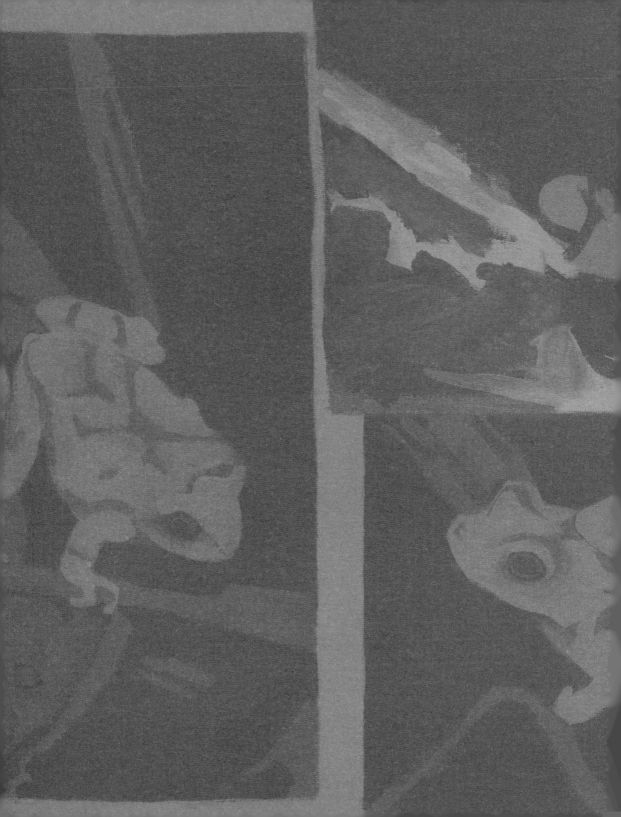

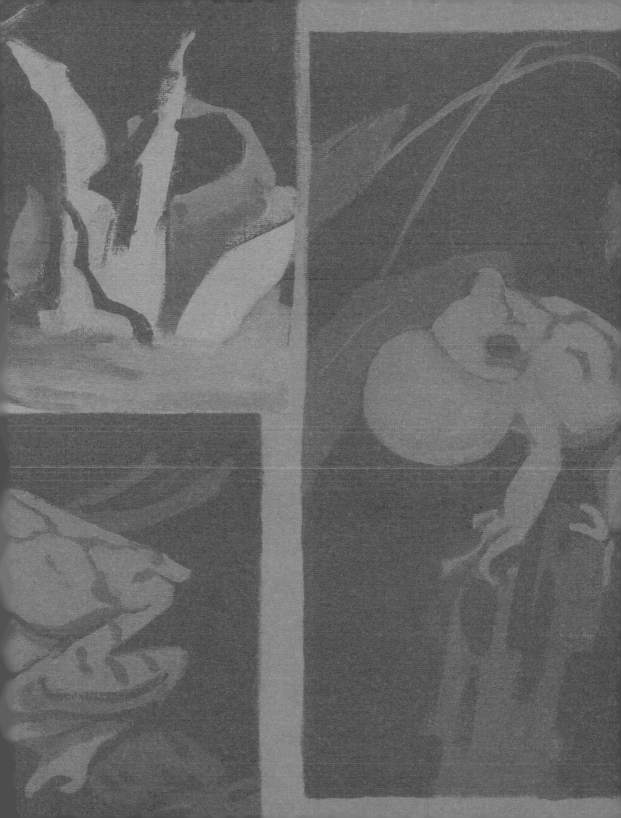

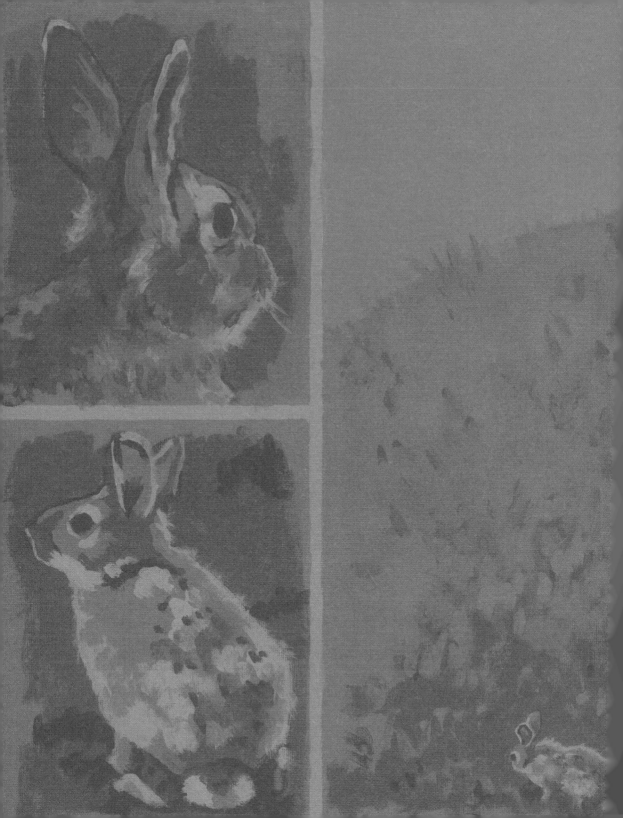

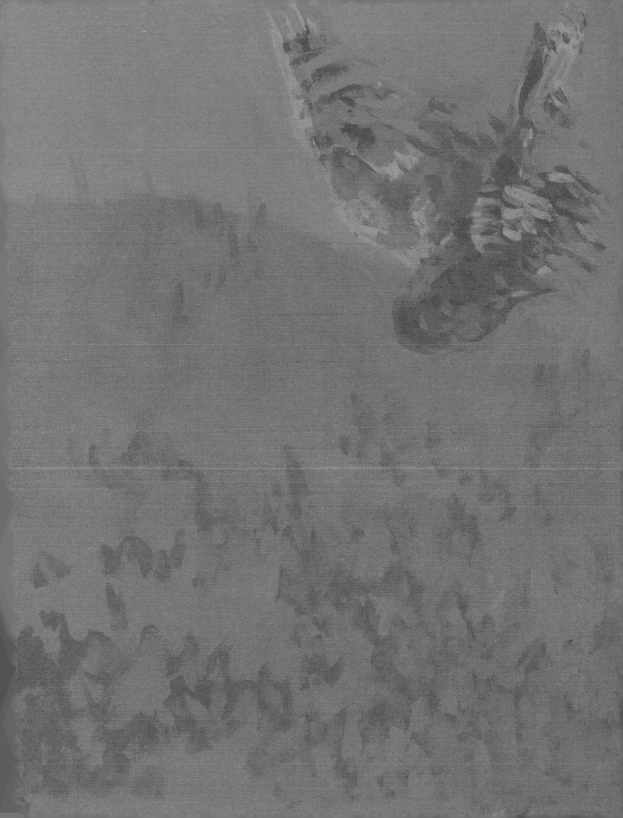

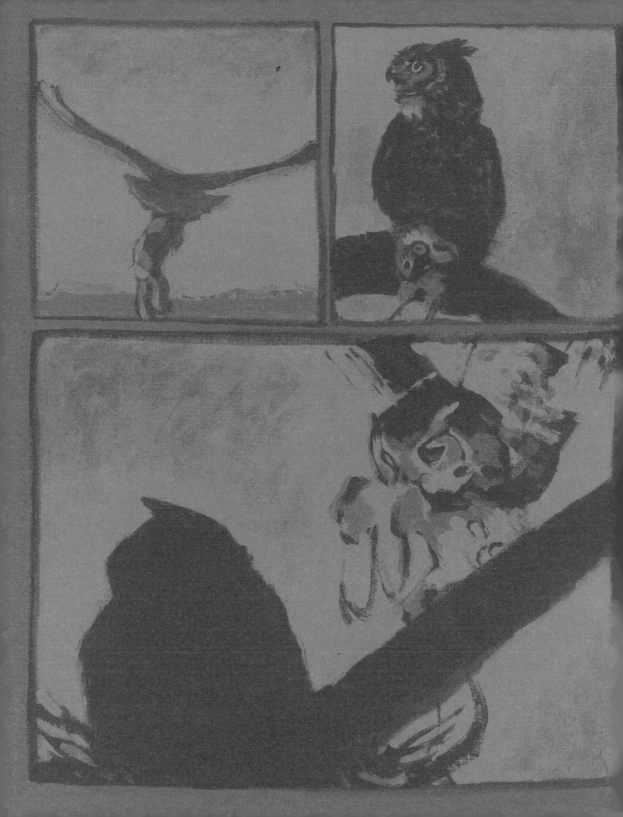

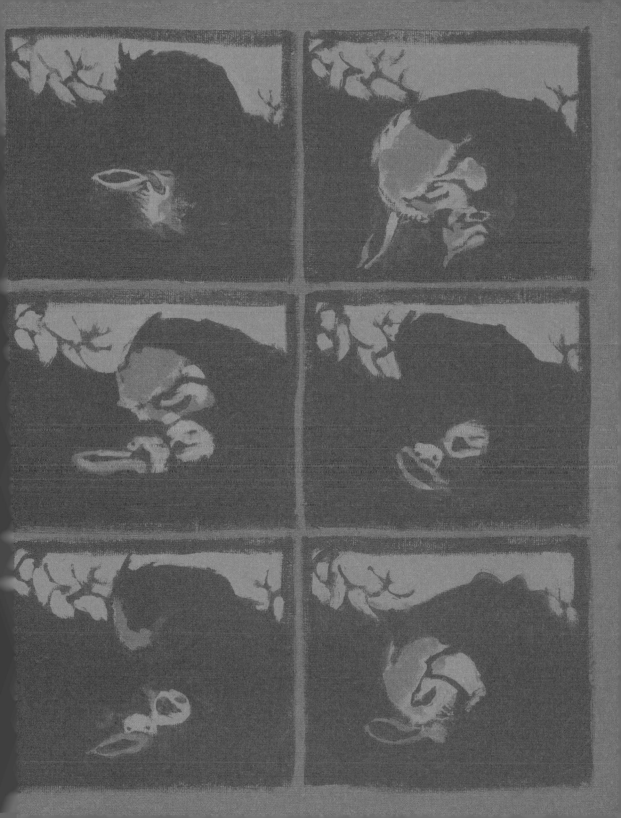

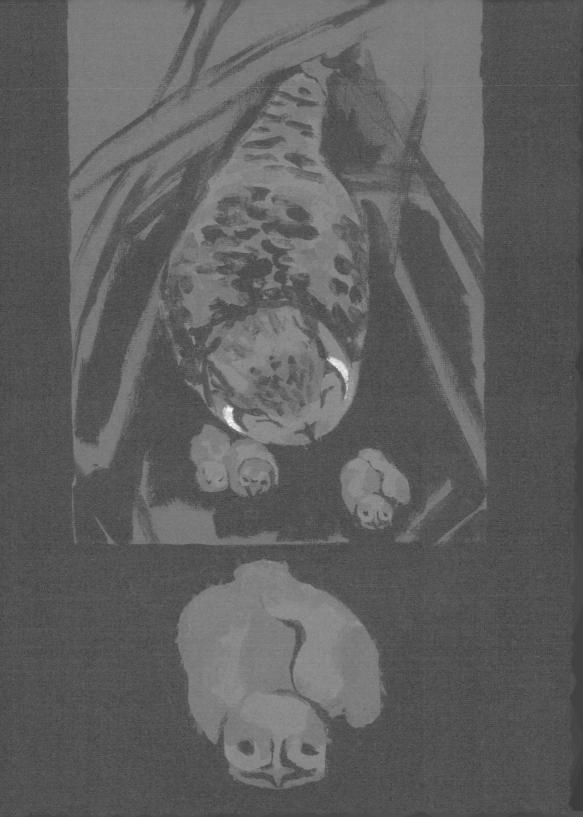

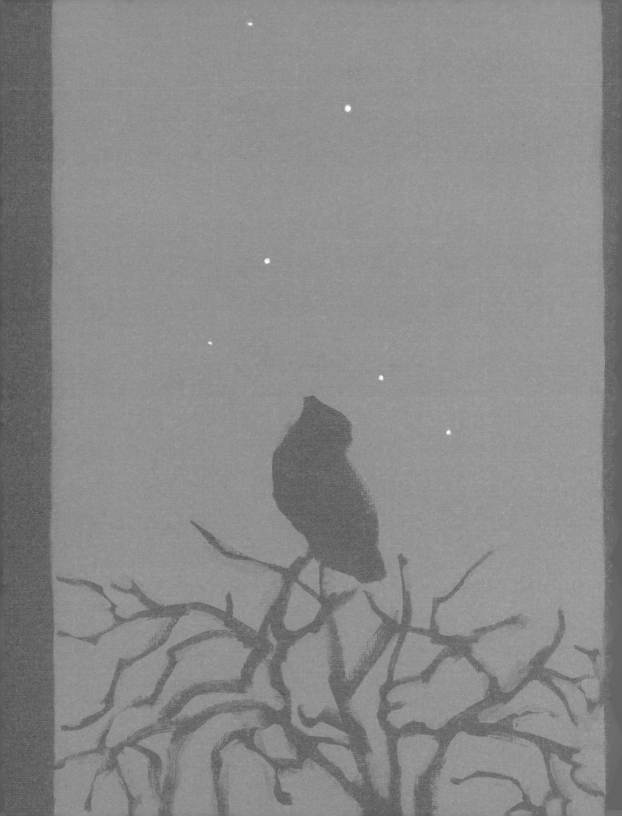

AFTEI

WORD

In 1998 I wrote a paper for my tenth grade biology class which was where the germ of this book first started. A decade later, in 2008, I used this paper to create a five page comic for 2dcloud's compendium *Good Minnesotan #3*. My paintings were printed in black and white and narrated with excerpts from the paper. Two years later, in 2010, I resumed work on it again, but with the intention of creating a graphic novel.

My intention was to create a documentary-style comic book about Great Horned Owls. I wanted it to be both educational and entertaining, both scientific and artistic.

One of my goals in *Sound of Snow Falling* was to express the life of a family owls as they really are. In order to do a book about Great Horned Owls as they are I read books, articles, watched videos, and even visited a few Great Horned Owl nests. I wanted to show that these birds are feeling and thinking beings with families that we can relate to but at the same time that they are not us.

When I began storyboarding the first pages of *Sound of Snow Falling*, I confronted a problem. It was easy to write that the owls hooted or hunted or hatched eggs, but what did those behaviors look like? I am deeply indebted to all of the people who uploaded their photos and videos online to share with the world. Their photo and video observations allowed me to watch and illustrate behaviors that I'd only read about.

Great Horned Owls are one of the most common species of owls in North America. You can find them in every habitat in the United States. However, they are most active at dusk and dawn and good at blending into their surroundings, so there were some behaviors that I found difficult to find footage for. When I needed more photo references of a particular behavior, sometimes I had to study images of other North American owls.

As a layperson who is deeply interested in science, I've always wondered about ways to make science more accessible to non-scientists like me. I wanted *Sound of Snow Falling* to be a science book that anyone can read. I hope that it gets people interested in the lives of the birds in their own backyards and in the lives of animals in general.

— Maggie Umber

References

Austing, G. R., and J. B. Holt, Jr. The World of the Great Horned Owl. Philadelphia: Lippincott, 1966. Print.

Bloem, Karla. Alice the Owl. Blogger, 7 Nov. 2004. Web. 18 Sept. 2010.

Click, Alessandra and Jeff Click. "Alessondra's OKC Great Horned Owl-Cam." Online live video stream. Ustream. Ustream, 22 Feb. 2013. Web. 21 Mar. 2013.

Duncan, James. Owls of the World: Their lives, Behavior, and Survival. Buffalo: Firefly Books, 2003. Print.

Gilbert, Jim. Minnesota Nature Notes: Exploring the changes in our backyards, fields, lakes, and woods--week by week, season by season. Minneapolis: Nodin Press, 2008. Print.

Glenshaw, Mark. Forest Park Owls. Blogger, 1 Mar. 2009. Web. 13 Feb. 2013.

Heinrich, Bernd. One Man's Owl. Princeton: Princeton University Press, 1987. Print.

Hoffmeister, D. F., and H. W. Setzer. "The postnatal development of two broods of Great Horned Owls (Bubo virginianus)." The Project Gutenberg. University of Kansas Public Museum of Natural History. 1 (1947): 157-73. Web. 11 Mar. 2013.

Lynch, Wayne. Owls of the United States and Canada. Baltimore: The Johns Hopkins University Press, 2007. Print.

Mona, Kirk. "Great Horned Owl on Motion Camera." Twin Cities Naturalist. Twin Cities Naturalist, 10 March, 2011. Web. 13 July 2012.

Patriotsgirl. "Great Horned Owls -- The Feather, New London WI - Ms. Harvey is served dinner -- 3-4-12." Online video clip. Youtube. Youtube, 4 Mar. 2012. Web. 21 Mar. 2013.

Pearman, Myrna. "Great Horned Owl Nest - Ellis Bird Farm, Alberta, Canada." Online live video stream. Sportsman's Paradise Online. Ellis Bird Farm, 13 Mar. 2011. Web. 23 Mar. 2011.

Reynolds, Cheryl. "Betty and chicks-Day 10 eating bunny ears-2nd chick." Online video clip. Youtube. Youtube, 2 Apr. 2009. Web. 26 June 2013.

Smith, Dwight G. Wild Bird Guide: Great Horned Owl. Mechanicsburg, PA: Stackpole Books, 2002. Print.

989razzle. "Eaglecrest Wildlife Great Horned Owl Calls to It's Mate 11-07-11 5:27am PST." Online video clip. Youtube. Youtube, 7 Nov, 2011. Web. 15 Jan. 2012.

989razzle. "Eaglecrest Wildlife Great Horned Owls Mate 1-29-13." Online video clip. Youtube. Youtube, 30 Jan. 2013. Web. 29 Mar. 2014.

989razzle. "Eaglecrest Great Horned Owl Pair Meet at Nest 11-07-11 5:48am PST." Online video clip. Youtube. Youtube, 7 Nov. 2011. Web. 15 Jan. 2012.

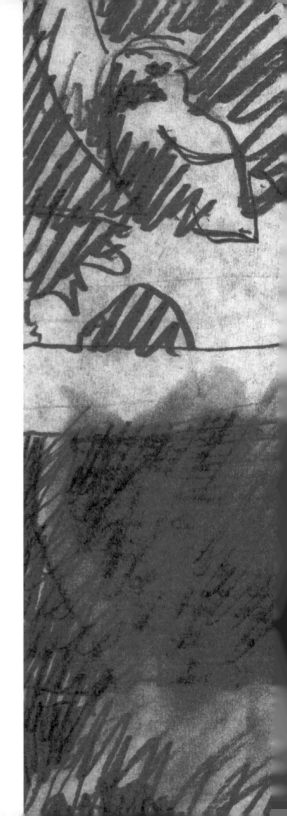

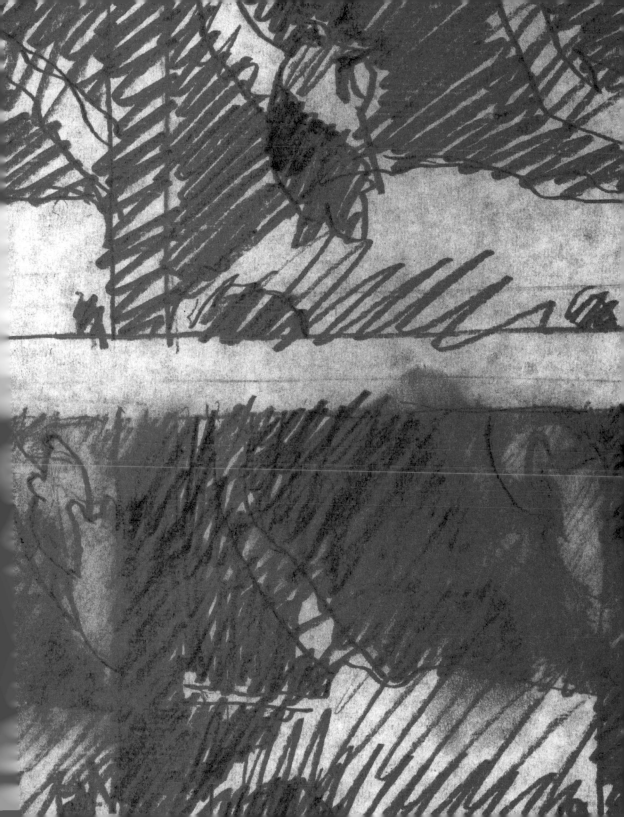

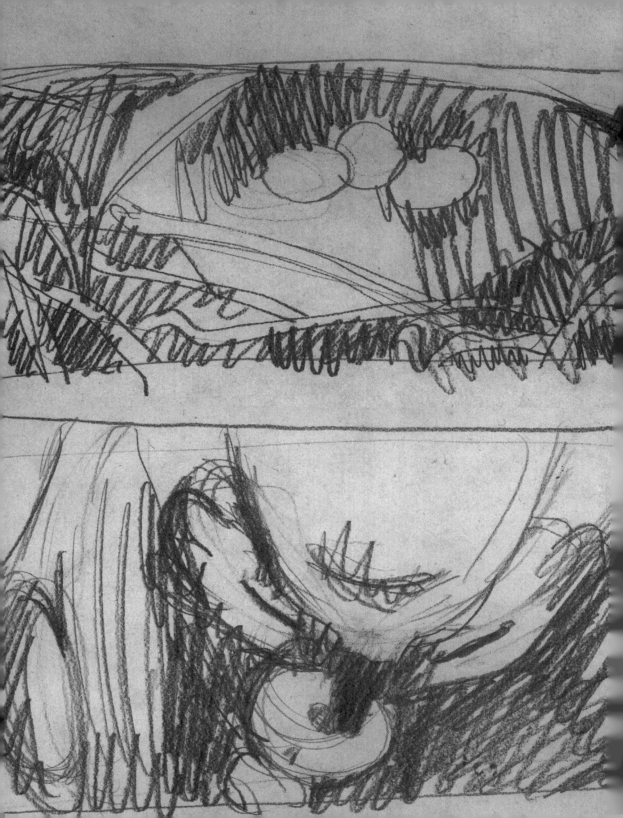

I dedicate this book to the Great Horned Owl couples whose lives taught me what it means to be an owl: Charles and Sarah of Forest Park, St. Louis, Missouri, Ellie and Albert of Ellis Bird Farm, Alberta, Canada, and Mr. and Mrs. Tiger of Alessondra's Owl Cam in Oklahoma City, Oklahoma.

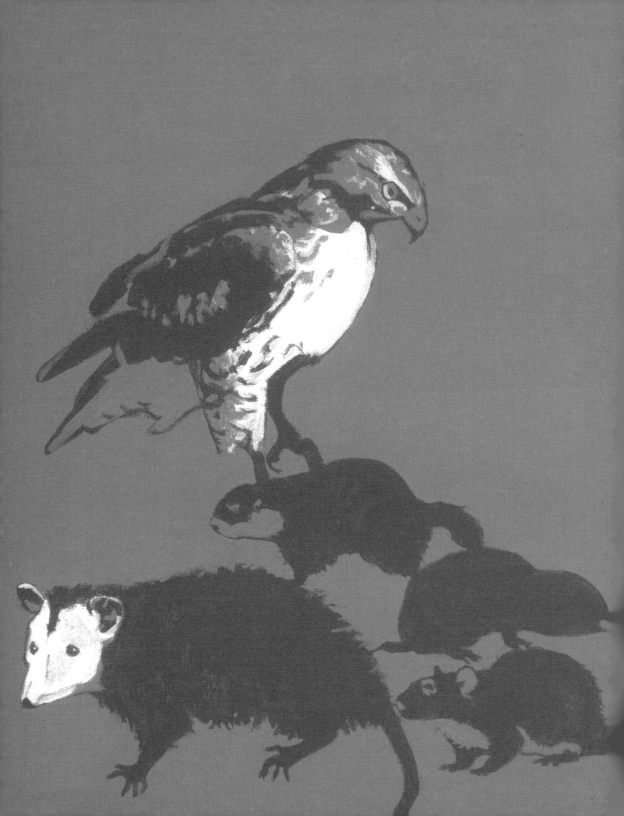